MURDER & MAYHEM IN
JEFFERSON COUNTY

MURDER & MAYHEM IN
JEFFERSON
COUNTY

Cheri L. Farnsworth

THE
History
PRESS

Published by The History Press
Charleston, SC 29403
www.historypress.net
Copyright © 2011 by Cheri L. Farnsworth
All rights reserved

Front cover images: Woman in center, portrait of Mary Farmer, 1908. *Printed with permission from
the Watertown Daily Times.* Electric chair at Auburn Prison. *Published by W.H. Zepp, circa 1914.*
Back cover images: Bottom image is a panoramic view of Public Square, Watertown, taken
by the Haines Photo Company, circa 1909. *From the Library of Congress Prints and Photographs
Division.* Photograph of carriage. *From the collection of Robert and Jeannie Brennan, Sackets Harbor.*

First published 2011

Manufactured in the United States
ISBN 978.1.59629.867.5
Library of Congress Cataloging-in-Publication Data

Farnsworth, Cheri, 1963-
Murder and mayhem in Jefferson County / Cheri L. Farnsworth.
p. cm.
Includes bibliographical references.
ISBN 978-1-59629-867-5
1. Murder--New York (State)--Jefferson County--History--Case studies. 2. Murderers--New
York (State)--Jefferson County--History--Case studies. 3. Jefferson County (N.Y.)--History,
Local. I. Title.
HV6533.N5F38 2011
364.152'3097475709034--dc22
2011007655

This book is dedicated to:

Joshua & Wilbur Rogers
Henry Dimond
Charles Wenham
Emma Baritau
Sarah Conklin
Julia Powell
Ella Allen
Mary Ward
Mary Crouch
Mary Daly
Mary & William Ockwood
Sarah Brennan
Roy & Jessie Burlingame

Rest in peace.

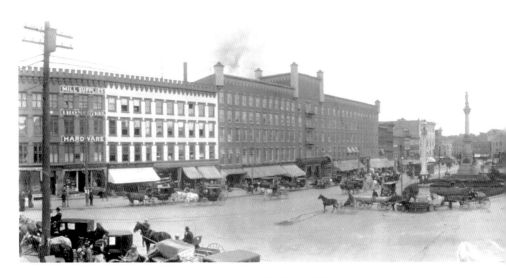

Panoramic view of Public Square, Watertown, taken by Haines Photo Company, circa 1909. *From the Library of Congress Prints and Photographs Division.*

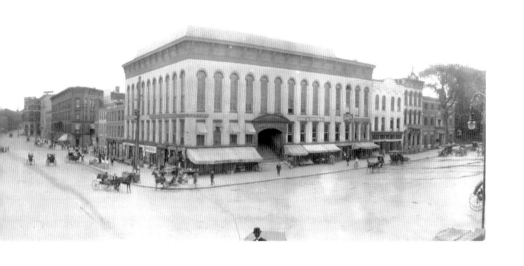

CONTENTS

PREFACE

While every effort was made to obtain original photographs or sketches of the individuals mentioned in this book, many of the images used in news articles written one to two hundred years ago have long since been destroyed or lost. And, while the vast majority of the county's voluminous newspaper archives have now been stored on microfilm or digitized, oftentimes the pages I found with photographs pertinent to this book did not scan well enough to republish. I was fortunate, however, to find some gems that *did* scan quite nicely, thanks to Lisa Carr, the *Watertown Daily Times* librarian, who assisted me in those efforts. Photographs and newspaper images in this book with captions that read, "With permission from the *Watertown Daily Times*," were taken from issues of the *Watertown Re-Union* and the *Watertown Herald* and are part of a collection held by the *Watertown Daily Times*. They were photographed and printed here with permission from the *Times*.

Because there were no photographs available for some of the stories, in a few cases, I improvised. From my personal collection, I carefully chose original antique photographs of unidentified locations and individuals who resembled what I perceived the victims and killers looked like based on obscure newspaper images and descriptive newspaper accounts. In the few cases where neither of those was available (like the first story from 1828), I had no choice but to use my imagination (and a bit of artistic license). The caption for such images simply says: *Courtesy of the author.*

ACKNOWLEDGEMENTS

I'd like to thank my commissioning editor at The History Press, Whitney Tarella, and my project editor, Amber Allen, for their continued enthusiasm and expertise; the New England sales rep, Dani McGrath; Jamie-Brooke Barreto of sales and marketing; and my publicist, Katie Parry, and assistant publicist, Dan Watson. They've all been a joy to work with on this and earlier titles.

Many thanks to *Watertown Daily Times* librarian Lisa Carr, for helping me find a number of images used in this book and for making it so fun (laughing about the big mess we were making). It was a dirty job, but someone had to do it, right? Another excellent photograph was kindly provided by Jeannie and Robert Brennan, the Sackets Harbor village historians—a big thank-you to them for taking the time to locate it (and to Connie and Larry Barone for seeing that I got it). I'd also like to thank Town of Brownville historian June McCartin, Village of Antwerp historian Jean Hendrickson and Jefferson County historian James Ranger for responding to my queries. The Jefferson County Historical Society calls the Paddock Mansion in Watertown, New York, its home. If you haven't visited, you must. I wrote about the Paddock Mansion in *Haunted Northern New York, Volume 4*, after visiting several times with the WPBS *Folklore & Frost Tour* and finding myself in awe of the many displays. The mansion is a wonderland for history buffs and researchers, and I'd like to give the staff a thumbs-up for their efforts in preserving county

history. I look forward to future visits, when I research *Wicked Northern New York* and *North Country Disasters*.

Most of all, I thank my husband, Leland Farnsworth II, for his encouragement, love and support. With all of the unexpected, emotional ups and downs this line of work sometimes brings, he remains calm, cool and collected, where others would cave; I would be lost without his strength. I thank my lucky stars every single day (not just each time I write a new book) for my beautiful daughters: Michelle, Jamie, Katie and Nicole. And I can never thank my parents, Tom and Jean Dishaw, enough for everything they do and have done, nor will I ever stop trying. (Special thanks for the you-know-what [*wink*] that helped make this book a reality.) Other essential shout-outs go to my in-laws, Carol and Lee Farnsworth; my siblings, Tom Dishaw, Christina Walker and Cindy Barry; and their families: Ed, Rachel and Ryan Barry, Danon Hargadin and Heather, Amanda, Bryan, Lindsey and Cade Alexander Walker.

INTRODUCTION

I like to think that we're a pretty tough lot up here in the North Country. We joke that when it drops to forty below and even hell freezes over, school might be delayed a measly two hours if we're lucky. That's how accustomed we are to extreme temperatures. But it's not just the climate we have to worry about in the winter months. It's the shorter days and decreased daylight of that time of year. An estimated one in ten people who live in northern climates like ours are plagued by serious mood changes each year between late fall and spring when the days are shorter. Its proper name is Seasonal Affective Disorder (SAD), but in its milder form, we might call it the winter blues. Severe cases of SAD, which is believed to manifest due to daylight and vitamin D deficiencies, exhibit symptoms such as depression, ranging from mild to suicidal; lethargy; lack of energy; hopelessness, anxiety, lack of tolerance, irritability; and social problems. Why am I telling you all of this? Because, besides the late summer murder-suicide of Jessie and Roy Burlingame in 1922 and the suspicious drowning deaths of Mary and William Ockwood in May 1897, all other cases in this book involved cold-weather murders. I can't help but wonder about a correlation between SAD and suicidal or homicidal tendencies in those most severely afflicted by it. But there's an expression northern New Yorkers have long been familiar with that mimics the symptoms of SAD and perhaps makes even more sense as a possible element in crimes of the past—cabin fever.

Except for winter recreation, like skiing, sledding and skating, we pretty much hunker down for the winter and stay inside for several months of below-freezing temperatures each year. But houses today are larger than they were one or two hundred years ago. Everyone has their own space. We have television, the Internet, telephones, gaming systems, mp3 players and everything imaginable that one would need to keep oneself entertained for hours on end. And we have nice warm vehicles that we can climb into on a whim to go for a drive—even in a snowstorm—if we get tired of staying in. Our ancestors had none of these things. They were cooped up inside for extended periods in the winter months with nothing to do; and if one person wasn't happy, I guarantee nobody was—they wanted out. That's cabin fever. The expression is synonymous with winter blues, as is SAD, and it's also analogous to going "stir crazy." According to Wikipedia (the online encyclopedia), it occurs with symptoms of excessive sleep or restlessness, forgetfulness, irritability, "irrational frustration with everyday objects" and "distrust of anyone they are with." That couldn't be good for families crammed together in tiny, cold log cabins in the days long before electricity and the automobile. Does it justify killing each other off? Of course not. (If they thought they were going "stir crazy" stuck at home with their families, imagine what serving a life sentence in the state prison system felt like!) I only mention cabin fever and SAD here in reference to the coincidental timing of the vast majority of the county's most sensational, historical murder cases. Eight of the ten murders described in these pages happened between late November and mid-April.

Another coincidence that couldn't be ignored was that half of the stories I wrote about involved women named Mary. Granted, Mary was the most popular girls' name in those days, but the fact that the name found itself enmeshed in so *many* sensational murder cases in just one county warrants mention. First, there was Mary Ward, who was shot in the back as she fled a gun-wielding madman named Henry Miles in the town of LeRay in December 1873. Then there was Mary Crouch and Mary Daly of Sackets Harbor, two best friends who were shot and killed (and dragged and burned) by George Allen-Haynes in April 1897 on their return from a pleasant outing. Haynes's motive for such an atrocity? He had asked Mary Daly to marry him, and they were to be wed that very weekend, but Haynes was already married to someone else *and* engaged to yet a third woman, and he had to

think fast to eliminate at least one of his problems. So he killed the women and attempted to frame Mary Crouch's ex-husband for the murders. Mary Ockwood met her untimely end under mysterious circumstances in May 1897 after departing by boat from Sackets Harbor with her husband. When her body washed up on shore, authorities were overly confident that she had been beaten to death, based on serious head wounds. So they blamed her husband, who was nowhere to be found—until his body, too, washed up on shore some time later. Last, but not least, was Mary Farmer. Mary Farmer was the epitome of a cold-blooded killer and was ultimately sent to the electric chair for her crime. She hacked her next-door neighbor, Sarah Brennan, to death in early April 1908 and stuffed her body into a trunk to conceal the deed. The next day, she moved into the victim's Brownville home—trunk and all—kicked the victim's bewildered husband out and attempted to convince him that Mrs. Brennan had left him and sold his house to the Farmers. You can't make this stuff up.

Brownville's other notorious "hack job," if you will, occurred in 1828, when Henry Evans took an axe to three men who had entered his home to evict him, mortally wounding two. Evans was subsequently hanged. The location of the murders has since been called "Slaughter Hill." In 1873, there were two well-publicized crimes. A young woman named Emma Baritau died at the hands of a doctor and spinster after an illegal abortion they performed on her between Christmas and New Year's Day; and Charles Wenham was beaten to death and thrown in the partially frozen Deerlick Creek following a well-orchestrated robbery. At least it *seemed* well-orchestrated, until the killers were caught. One snuck a lethal dosage of strychnine on the way to jail and successfully killed himself before the people could get to him; the other, Charles Sutherland, was sent to the gallows to pay the ultimate penalty. Thus, three men lost their lives in the fray—all over a lousy $125.

Sarah Conklin met her fate in the town of Rockland on November 30, 1875, shortly after school got out. It was one of the rare occasions when her father didn't come to school to pick her up, so the eleven-year-old was enjoying a rare taste of freedom as she made her way through the woods toward home that day. She was wearing a warm, red riding hood when she walked straight into the trap of killer, and it wasn't the big bad wolf. Frank Ruttan, the accused, was a brute of a boy at fourteen. He allegedly waited for the victim after seeing her leave school alone from the upper level of

the barn where he worked. Then he beat her, choked her and left her for dead. The little girl had rejected his advances and tattled on him several weeks earlier, and he was determined to get his revenge. But revenge is not so sweet when the price to pay is life imprisonment. Although Ruttan got what he deserved, George Powell never did. Powell was implicated in two well-publicized Sterlingville crimes. First, in March 1876, his young wife, according to Powell, walked down to the creek a short distance from their back door and proceeded to "drown herself." Instead of diving in after her, even though she had just barely turned up missing, he went to find a neighbor to undertake that grim (and chilling) task, telling investigators that he wasn't good with "that kind of stuff," meaning dead bodies and such. Everyone, it seems—neighbors, investigators, and even the district attorney—felt he knew far more than he was saying, since his wife's body was covered with fresh bruises, indicating foul play. Still, he insisted she had been unwell and despondent after having lost a baby two months before. Lucky for George Powell, the investigation was mishandled from the start, and he was never even asked to give a sworn statement for the coroner's inquest, so he wasn't charged with anything. That same year, just before Christmas, only six months after his wife's suspicious death, Powell's name made the news again. This time, he attempted to procure an abortion on a girl he had recently hired as a domestic servant. He sent Ella Allen away to a doctor in Philadelphia, New York, who performed the illegal procedure for which Powell had already paid. The ordeal nearly killed her and left her suicidal. Powell seemed to have that effect on women.

Needless to say, Jefferson County—one of seven counties that make up the northern New York region—has had more than its share of historic true crime. Although settlement of the rugged terrain began in the 1790s, the county was officially born in 1805. That same year, its seat—the hub of activity for countywide criminal proceedings—became Watertown, the county's only city. In August 1828, Henry Evans had the distinction of becoming the first man to be hanged in county history. Today, he has the distinction of being the first killer discussed in this book. In 1862, the third and current county courthouse was built at the intersection of Arsenal and Sherman Streets, just two blocks west of the Public Square historic district (or city center). It was there, in the red brick and limestone courthouse still standing, that every single murder case in this book, except that of Henry

Evans, was tried. Think about that the next time you drive through Public Square toward the familiar County Courthouse Complex. Think about the killers taken by horse and buggy along that same route in shackles and handcuffs one or two hundred years ago (not to mention the killers driven by squad car in more recent times). The journey to the Jefferson County Courthouse—for those who have done wrong—has always been one filled with dread and uncertainty. It surely was for the people involved in the following stories, for it was there that justice was served, and it was there that they learned their fate, be it freedom, death by execution or incarceration.

While most locals are familiar with the twentieth-century murders of Patsy Vineyard, Irene Izak, Cherie Dobbin, Christine Vaadi and Bonnie Hector—to name just a few—not many people are aware of the equally sensational murders of the nineteenth century and early twentieth century. That's where this book comes in. You already know the contemptible deviates, like Arthur Shawcross, Stuart Moss and Adrian Rusho. Now, let me introduce you to the worst killers of yesteryear.

CHAPTER 1

THE AXE MURDERS ON SLAUGHTER HILL

BROWNVILLE, 1828

On a late winter's eve in 1828, during "an act of savage brutality," as the *Watertown Herald* later called it, Henry Evans hacked Joshua Rogers and Henry Dimond nearly to death and seriously injured Joshua's brother, identified as Nathaniel in one source and Wilbur in another. (I refer to him as Wilbur, the name used in my earliest source.) The carnage took place on Perch River Road, County Road 54, between Brownville and the Village of Perch River, northwest of Watertown, in an old log house that was allegedly being leased to Wilbur Rogers and subleased to Henry Evans at the time. (Either that or the "brute in the shape of a human being," as the *Herald* described him, "moved his family into [the] unoccupied log house without the authority of the owner.") Regardless of how Evans came to live there, Wilbur and Joshua Rogers decided it was time for him to leave. But their mother and other brother, Benjamin, thought it was wrong to evict him. After all, he may have had a temper; he certainly liked his booze, but so did they; and he had a young wife and small children to provide for. Their arguments fell on deaf ears.

On April 16, Wilbur hatched a plan and made Joshua and Dimond his willing accomplices. After a hard day's work splitting fence rails and drinking enough to build up their courage, they decided "without any legal formality to eject Evans from the house." Benjamin Rogers, the good brother, stated for the defense that, the night before the murders, Wilbur said he intended

Courtesy of the author.

to take Joshua and Dimond with him to evict Evans. So Benjamin found Evans and gave him a heads-up to lock his doors and be prepared for the troublesome trio to show up. He couldn't have imagined how far Evans would take it. Right on schedule, as forewarned, Joshua and company showed up at Evans's door at dusk the next day and knocked; when Evans asked, "Who's there?" they refused to answer—not that it mattered. Evans knew who it was. He had been expecting them. What he hadn't expected was for them to break down his door and come barreling into the cabin, threatening him and his horrified family.

Newspaper accounts say that Evans told Dimond to get out and close the door, that it was his house, not theirs. Twice he told them to leave. Instead, they proceeded toward him menacingly, and when they were about to remove him by force, according to the *Herald*, "Evans seized his axe from under the bed and struck [Wilbur] Rogers, making a severe gash on his shoulder." The

The Axe Murders on Slaughter Hill

Sketch by Alfred R. Waud, circa 1860. *From the Library of Congress Prints and Photographs Division.*

tables had turned. As the stunned men scrambled to escape, Evans "gave Joshua Rogers a blow in the neck, and he threw the axe at Henry Dimond, inflicting a mortal gash from which he died in ten days." Joshua died the next day. Wilbur, the mastermind of the ill-conceived plot, lived a number of years, according to one source (a different source says that he, too, died in the scuffle). That was the day "Slaughter Hill" was born.

Word travels fast in a town so small, and Evans must have thought he acted appropriately to protect himself and his family, for he never even attempted to flee the scene. He was quickly arrested, locked up in the county jail, indicted by the grand jury for murder in the first degree and tried in the old stone courthouse before Judge Nathan Williams on June 23, 1828. Robert Lansing, the district attorney, was assisted by John Clark; Evans was

defended by Micha Sterling, Isaac H. Bronson and James Rathbun. Evans's reputation had preceded him. It took the jury only thirty minutes to reach a solid verdict: guilty.

According to a *Watertown Herald* article of May 16, 1908, called "Hanging of Evans":

> *The vicious temper and abandoned character of Evans, who, whether drunk or sober, had been the terror of the neighborhood in which he lived, outweighed the extenuating circumstances of the case; and the jury, after a half hour's deliberation, returned a verdict of guilty of murder in the first degree. He treated his wife and children with great brutality. He once, to punish a child, held its finger before a blazing fire until the ends were blistered.*

Thus, Evans was sentenced to be hanged on August 22, 1828. It would be the first such execution in Jefferson County. The gallows was erected on the high ground on the north side of the river on a vacant lot at the corner of LeRay and West Main Streets in Watertown. An estimated ten to fifteen thousand people came from around the county to witness the execution, traveling in loaded lumber wagons in the days before carriages. They blanketed the south side of the river to catch a glimpse of the doomed man and the gallows from afar. According to the *Register* of August 28, 1828, a weekly paper published in Watertown in 1828, "at 9 o'clock, a guard of infantry and cavalry was stationed around the gallows where the crowd had already begun to collect, and at 2 the culprit was escorted thither from the jail," walking with a firm step that belied his trepidation.

The *Herald* elaborated, saying:

> *The condemned man was led upon the platform by the sheriff with his wrists jeweled with hand cuffs. The Rev. Jedadiah Burchard, a young man who became noted as the most eloquent pulpit orator in the County, performed the duty of Chaplain. After which the culprit asked that the assembled crowd join in singing the well-known and popular song, a great favorite, for his benefit:* A rose tree in full bearing, hath sweet flowers fair to see, one rose beyond comparing, for its beauty attracted me. *The Chaplain led in the plaintive tune and was joined by*

more than 1,000 voices. At the conclusion of the services, the block cap was placed upon his head and the noose adjusted about his neck, as he stood upon the fatal drop which was held in place by a rope.

Because Evans seemed as if he might faint while the noose was being adjusted, the constables at either side of him steadied him. In his farewell speech, Evans said: "What I have done, I have done in defense of myself and family," according to the *Herald*. And he truly believed that. He then "urged the sheriff to hasten the execution, exclaiming, 'For Jesus' sake, do let me down.'" The sheriff, Henry Hale Coffeen, severed the cord with one blow, and the body fell three feet, breaking Evans's neck. Still, his body writhed for an agonizingly long ten minutes after the drop fell, according to the *Herald*, which added, "The dead body was taken to Brownville by some friends and a grave was dug in the cemetery; but objections being made to his burial, a grave was dug outside the corporate limits which called forth further objections."

Those objections were due to reports that Evans was roaming at night as a vampire seeking revenge after a few short days of being interred there. Superstition was alive and well in early nineteenth-century Jefferson County. (A vampire, by one common definition, is a blood-sucking ghost.) The panicked community saw fit to have Evans's friends dig up the body again and move it to an undisclosed location even farther from the village. The *Herald* then reported, "The corpse was finally taken three or four miles from the village by night and buried in an unmarked grave that has never been found to this day."

CHAPTER 2

MAN BELOW THE ICE: THE WENHAM MURDER

GREAT BEND, 1873

On Tuesday morning, January 7, 1873, a frozen body was found under the ice in Deerlick Creek, about two miles from Great Bend and twelve miles from Watertown. Traces of blood and suspicious footprints dotted the roadside in front of the farm of Samuel Fulton and marked an ominous trail leading to the gruesome find. George Ware was first to stumble upon blood droplets in the snow while walking down the road that morning. He asked neighbors Tabar Clark, Mr. Fulton and Fulton's son to help him track the footprints, which led the men to a clump of willows. There, beneath the ice, was a lifeless, face-down body of an adult male. "The men turned the body on its side to look at the face and let it back again, where it remained until the arrival of the Coroner, about half past five in the afternoon," according to the *Cape Vincent Eagle.* Finding the body again, however, proved a daunting task due to a blinding snowstorm that filled in the creek with snow that afternoon. When the body was finally located by the men, who were then accompanied by Coroner Lewis and Constable N.H. Merrill, the dead man was taken first to Fulton's home and then later removed to Watertown. There, a postmortem examination was held by Dr. Johnson of Watertown and Dr. Ferguson of Carthage.

The *Jefferson County Journal* said:

> *A post mortem examination revealed some wounds about the head, probably made by a club which rendered the victim insensible, when,*

Postcard of Deerlick
Creek, circa 1907.
*Published by The
American News
Company, New York.*

*after robbing him, the murderer carried him to the creek and threw him
in. Mr. Fulton and daughter testified to seeing a cutter with two men
in it go by the house and stop by the roadside, where the traces of blood
were found, and remain there about one-half hour. This was just after
dark Monday night, and the cutter soon afterwards came back and went
towards Carthage. The pockets of the murdered man had evidently
been rifled, for nothing of value was found in them; but inside of the
undershirt, in a small pocket, was found an envelope addressed to Charles
Wenham, Carthage, N.Y., care Wm. Davenport, containing $100, and
in the vest pocket was found a letter, in the same hand writing as that on
the envelope, which read as follows:*

"Pinckney, N.Y., Dec. 24, 1872

Dear Charley:—I want to see you in the worst way. I had a letter from a friend of mine in Cleveland, Ohio. He wants me to go up there. He owns some street cars in the city. Wants me to go and be a conductor and says that if I have a friend to take him along. He will pay $35 a month. Now, I want you to come and see me before you hire with William Davenport. Be sure and see me first. Do not tell any person about this, as I do not want any person to know where I am going. Try and come up to-morrow or some night this week.

Charlie Sutherland

I wish you a merry Christmas."

Thus, the authorities had their first clue to the identity of both the victim and his killer, and robbery appeared to be the motive. While $125 was missing, the $100 the victim had sewn into his undershirt to keep it secure was somehow overlooked by his killer or killers. The body was identified as that of Charles Wenham, a twenty-three-year-old who had come to this country from England only a year before in search of employment opportunities. His family remained in England. The killer was believed to be Charles Sutherland, a Canadian whose family was said to be reputable and wealthy. The twenty-two-year-old shouldn't have been hurting for money. He had become acquainted with the victim when Wenham was hired by William Dryden, a relative of Sutherland's, for whom both young men had worked at one time. The two always seemed to be "on the best of terms," according to the *Jefferson County Journal*, which added that Sutherland "always bore a good character and was engaged to be married soon."

From the facts that could be gathered, on January 6, 1873, Sutherland and Wenham left Copenhagen via a horse and cutter belonging to Sutherland's employer (farmer Henry E. Bushnell of Pinckney) en route to Carthage. Wenham had planned to "take the cars that evening on his way to California." He seemed eager to move to the much-milder southern California, and it was no secret to Sutherland that Wenham had been saving money for the move. On the morning Wenham was to set out for California, it is believed that Sutherland offered to drive him to Watertown to catch the train. The two then left Carthage and headed toward Great Bend on the Martin Street road—and Wenham was never seen alive again. About 6:00

p.m., the horse and cutter paused for nearly a half hour at the place where the murder allegedly occurred, according to witnesses later questioned. Because the young men had last been seen together at that location, and Wenham obviously had never left the spot, Sutherland was the prime—and only—suspect at the time. Further investigation revealed that, on the evening of the murder around 8:00 p.m., Sutherland returned to the Lewis House alone, got a room and retired to bed. The next morning, he was seen breaking open Wenham's chest in the sitting room of the house and transferring its contents—clothes, a watch and a chain—to his own new trunk. Then he returned to Bushnell's farm in Pinckney.

With strong evidence now pointing the finger at Sutherland, Chief of Police Guest, Deputy Sheriff Budd and Constables Hubbard and Irvin set out to locate the young man late in the evening of Friday, January 10, 1873. But due to a snowstorm, "the roads were drifted full, and the party were 2½ hours in going 6½ miles," according to the *Jefferson County Journal*. There were no snowplows or road crews working to clear the way in those days. Finally, around 1:30 a.m. on Saturday, about ten miles from the crime scene, they arrived at John Dryden's farmhouse and found that Dryden had "sent for and got Sutherland"; the young man was in bed. Dryden woke him up and told him to go downstairs where the officers informed him that he was going to go to Carthage with them. Sutherland denied involvement in the murder, as expected, but was unable to explain where he got the $91 that was found in his possession. He was handcuffed and put in the sleigh. But shortly after starting for Carthage, Sutherland became ill and complained of feeling warm and needed his muffler loosened. They thought he was merely "sick with fear" until he went into convulsions, at which point they realized he must have ingested poison. He barely had time to deny the latest accusation before taking his last breath. There was nothing the lawmen could do to revive him, so the solemn journey continued in the storm, and the men arrived at their destination with their lifeless cargo two hours later. Dr. Peden examined the deceased and confirmed that he had, indeed, succumbed to strychnine poisoning; a bottle containing the potent poison that was found in his pocket corroborated that finding. He purchased the bottle on January 2—four days before the murder—at John Raymond & Sons in Copenhagen, proving the likelihood that the crime was premeditated. Apparently, the authorities surmised, Sutherland swallowed the poison just after the officers

arrived at Dryden's farm, when he went upstairs alone under the guise of needing to change his clothes and gather his belongings. The *Jefferson County Journal* said, "The summary way in which the guilty man took his own life has saved the county some thousands of dollars' expense and added another awful crime to the already-blood-stained soul of the murderer."

In a *Watertown Times* article dated January 12, 1873, District Attorney Williams said, "We have the murderer, but he has cheated the gallows. Probably no one else was connected to the murder." Four days later, the *Cape Vincent Eagle* reported, "The Coroner's inquiry shows some evidence of a third person in the transaction, as an accomplice of Sutherland; but there is nothing definite upon which to found such a belief." A bit later, it said, "Sutherland undoubtedly had an accomplice, but nothing is known as to whom it was."

Enter Hiram Smith.

A year after the murder, Smith apparently made some comments incriminating himself, while under the influence of a substantial amount alcohol, to Hiram Ingram and grocery store owner O.S. Prindle. The men said Smith bragged about having been an accomplice to the crime. Drunk or not, those careless words sealed his fate. One of Jefferson County's most sensational murder trials followed. The indictment charged that both Smith and Sutherland schemed to get Wenham to go for a ride with them with the money they knew he had before leaving the North Country. It further said that they laced some liquor with strychnine to try to poison him, but it didn't work, because the liquor "acted as an antidote," according to prosecutors. When Wenham fought back, they beat him with a large club, cracking his skull and shoved his body under the ice of the creek. Defense attorneys N. Whiting and L.H. Brown couldn't save Smith.

The jury returned a verdict of guilty, and Judge O'Brien ordered Smith hanged by the neck until dead. To the jury, it was a cut and dry case. To the public, there was plenty of room for doubt. According to a column called the Grumbler's Pen in the June 6, 1908 edition of the *Watertown Herald*:

> *Smith was in company with the two men the day of the murder; and to make himself brave enough to enter the band Prindle outlined, told of his having a hand in the murder, describing the scene as it had already been pictured in the daily newspapers, telling where a bloody scarf might be*

Attorney Levi H. Brown. *From Emerson's* Our County and Its People *(1898).*

found tucked up under the timbers of the bridge. The conflicting testimony of the people along the road as to whether there were two or three men in the cutter going toward the Bend; whether one or two returned; the finding of the scarf, which Smith had hid after his first interview with Prindle, as was claimed; and Smith's story to Prindle with a hidden witness present, were told in court, discussed by the people, and there are many who will never believe that Hiram Smith was guilty.

The people of the region did not believe Smith should pay the ultimate penalty for a crime he wasn't implicated in, or arrested for, until a full year later. They believed he was set up by Prindle and were outraged. When the *Carthage Republican* reported that Prindle should be paid a thousand bucks for his role in Smith's fate, the statement struck a raw nerve within the community. The paper lost advertisers and subscriptions over the gaffe, and Prindle was forced to leave Carthage due to the storm of negativity at which he found himself in the center. But none of the support for Smith (or the sudden disdain of Prindle) could prevent the fate that awaited Smith. The execution was stayed once, having originally been scheduled for July 24,

1874, but then the date of execution was set for December 4, 1874.

The *Cape Vincent Eagle*, recalling the event, said:

> *Forty years ago today, the second and final hanging in the history of Jefferson County took place in this city in the neighborhood of the present county jail and where Waltham Street now cuts through…More than one* [witness to the hanging] *today voiced the opinion that, while Hiram W. Smith paid the death penalty on the gallows for the murder of the Englishman Wenham, it was really his partner in crime, Sutherland, who committed the deed and took poison as he was about to be placed under arrest.*
>
> *The hanging took place in the early forenoon of a day which Alfred McCutcheon today described as warm enough so that overcoats were unnecessary…The gallows had been erected in a stockade, perhaps 20 feet in height. On the night before, Mr. McCutcheon recalls, two companies of the militia were called out and pickets placed about the jail and a line drawn to keep the crowd back. Some fears were entertained of a jail delivery, and Sheriff H.D. Babbitt determined to take no chances…The body was later taken to Cape Vincent, where the funeral services were held.*

The scaffold for the hanging was built near a corner of a high stone wall that had been built during the Civil War era for defense purposes. McCutcheon, a young man at the time who managed to witness the scene (before closing his eyes and turning away at the moment Smith was killed), recalled that, shortly after 10:35 a.m., the sheriff and two deputies escorted Smith to the scaffold. Smith walked with a "firm step, holding his head erect," he said. And when he had taken his place beneath the noose, he looked up toward the sun one last time before the black cap was placed over his head and the noose adjusted around his neck. Then, in an instant, he was plunged to his death. A physician pronounced him dead, and the body was removed. Captain Alfred McCutcheon, the young McCutcheon's father, along with four soldiers from the Thirty-ninth Separate Company, delivered the body to the train depot to be sent to Cape Vincent for funeral services. Smith was buried in a little cemetery at Fox Creek. The question of his guilt has never been satisfactorily answered.

DYING TO BE GOOD

ANTWERP, 1873

Great excitement in the neighborhood—abortion and death—arrest of Dr. Seymour and
Mrs. Sprague—taken to Ogdensburg.
—Watertown Re-Union, *January 23, 1873*

They dubbed it the "Antwerp Sensation" for the public interest generated
when a young servant woman named Emma Baritau became the victim
of an apparent botched abortion in the town of Antwerp in 1873, for which
a doctor and "vixen" were arrested. Because of societal views of unwed
mothers in the late 1800s, many young women—to save their reputations
and that of their masters or whomever got them pregnant—were sent away
to have the pregnancy "taken care of." In effect, they were *dying* to be "good,"
for "good girls" didn't get pregnant out of wedlock. But the lack of proper
skill, hygiene and medical paraphernalia by midwives and medical personnel
looking to make a quick buck off another's misfortune resulted in a wave of
abortion-murders and deaths at the turn of the century. Even with New
York state abortion laws that had been in effect since 1830, countless doctors
risked incarceration and the loss of their medical licenses to perform them.
Sadly, there was always a demand for the clandestine procedure, making it
potentially a lucrative business for those willing to put their livelihoods on
the line. The law stated that any attempt to induce abortion at any stage
of pregnancy, by any means (i.e. drugs, instruments, etc.), was considered a

Postcard of Antwerp, circa 1907. *Published by the United Art Publishing Company, New York City.*

misdemeanor punishable by up to a year in prison, and a successful abortion after quickening (when a woman first feels fetal movement between fourteen and twenty-one weeks of pregnancy) was considered to be second-degree manslaughter. The exception, in New York State, was if abortion was clearly necessary to save the life of the woman, as advised by two physicians. Whereas the 1830 laws were designed to prosecute abortionists only, in 1845, the law was amended to make a pregnant woman who knowingly submitted to an abortion guilty of a misdemeanor, as well, regardless of whether she was forced to undergo one against her will, which was often the case.

According to the *Watertown Re-Union* of January 23, 1873, Emma Baritau was a girl of "not more than 20 years of age" who had come to Antwerp from the town of Wilna where her family lived while searching for work a year earlier. She was "good looking and engaging in appearance" and was said to have been "modest and hard working." She was first hired by the Proctor House hotel as a servant, or dining room girl. Then Frank Swan hired her, and she went to live with him. Two days before Christmas in 1873, the young girl was sent from her employer's house to the home of the widow Arizilla Sprague (some sources call her Alzina). Sprague was an "elderly vixen of notorious antecedents and exceedingly doubtful virtue" who lived just over the county border in the town of Fowler, several miles east of Keene's Station. Sprague was described as a heavy-set woman with

a dark complexion who was about fifty years old—not exactly what I would call "elderly," as the *Re-Union* called her. Her manner was said to be "quite reticent and apparently of great firmness," according to the *Daily Journal* of January 18, 1873. Emma spent her final holidays with Sprague, a woman she had never met, when she should have been spending them with family. At the time of her arrival, Emma was "sprightly and apparently well," according to the *Ogdensburg Journal* of January 14, 1873. On New Year's Eve, Dr. Seymour of Antwerp was called to the home. Eight days (and three more doctor's visits) later, the young and vibrant woman was dead. Her body was identified by a milliner named Miss Aurilla Wight of Antwerp.

Coroner Dr. J.R. Furness of Ogdensburg was summoned to the scene to perform an inquest, and a postmortem examination performed by Dr. Parmelee of Gouverneur revealed an abortion had been performed on the young woman. To that, Dr. Seymour testified that "an operation for

Courtesy of the author.

miscarriage was performed before he was called in." Call it what you will, but he was still looking at manslaughter. Furthermore, he said that the second time he visited the home, the girl had given birth to a premature baby who was left at the house. If such was the case, the body of the infant could not be produced, and Mrs. Sprague denied ever seeing a baby. Clearly, one of them was not being entirely forthcoming.

The *Journal* said:

> *The testimony of Dr. Seymour and Mrs. Sprague, taken not in the presence of each other, was conflicting in many important particulars and indicated to the minds of the jurors that those witnesses were the persons who performed the operation which resulted in the death of the victim, and they gave as their verdict that the said Emma Barito [sic] came to her death from the effects of abortion performed by the hands of Dr. E. Seymour and Mrs. Arizilla Sprague.*

Coroner Furness notified District Attorney Brinkerhoff by telegraph of his findings, and a warrant for the arrest of Mrs. Sprague was delivered to police officer J.H. Murphy; while a warrant for the arrest of Dr. Seymour was delivered to Officer William Earl. Both were subsequently arrested and taken to Ogdensburg, where they were brought before the justice of the peace, since the tragedy of the Jefferson County girl occurred just over the border in St. Lawrence County. Brinkerhoff then questioned the pair. Testimony was also taken of Coroner Furness and Dr. Parmelee, who performed the postmortem examination and reported the cause of death; Mr. Proctor, the victim's employer, who swore to the time and date that the victim left his house to go to Mrs. Sprague's; and Miss Aurilla Wight, who identified the body. The testimony of several important witnesses was postponed because the trains they were to arrive on experienced delays. So Coroner Furness and Dr. Parmelee were brought in for additional testimony relating to the condition of the body when they were first called to the scene.

While the *Re-Union* had previously made no bones about their contemptuous opinion of Mrs. Sprague, they heaped praise on the doctor, saying: "Dr. Seymour is a young physician of excellent character and is deservedly popular in Antwerp and wherever known. He will doubtless be

From the Library of Congress Prints and Photographs Division.

able to vindicate himself fully from the charge of criminal malpractice." They were correct.

The *Ogdensburg Journal*, on January 17, 1873, said:

> *On Friday (to-day) the case came on again, and, as the evidence was not sufficient to hold Dr. Seymour on the heinous charge, he was discharged from custody. Mrs. Sprague is still held, and her examination is now going on…After having been discharged, Dr. Seymour was put upon the witness stand for the people against Mrs. Sprague, and enough evidence was elicited to make a case. Mrs. Sprague was held for trial for the murder of Emily Barito [sic] and her child by forcibly producing an abortion, and a warrant was made out for her committal. She left here for Gouverneur this evening for the purpose of procuring an order, if possible, to admit her to bail.*

Alzina Sprague was arrested and held on $2,000 bail to await grand jury action. She was discharged two months later, according to the *Ogdensburg Advance*, because "the Grand Jury [was] unable to find a true bill against her from evidence which was brought before them." Thus, as was so often the case in similar situations at the time, nobody was held accountable for the murder of Emma Baritau or her unborn child.

THE BRUTAL SLAYING OF LITTLE SARAH CONKLIN

RUTLAND, 1875

They speak of her as a beautiful girl, large of her age, and of extraordinary development. She was the pride and comfort of her adopted parents, whose grief at her terrible death is very great.
—Watertown Re-Union, *December 9, 1875*

On November 30, 1875, ten-year-old Sarah Conklin left School No. 13 in the town of Rutland around 4:00 p.m., walking home. Her teacher, Mrs. Martha Andrews, saw the young girl walk to the edge of the school property with a few other students before continuing on her way alone as darkness began to fall. A farmer by the name of Elbert Fuller saw the child walking toward the woods behind the schoolhouse that afternoon, taking a path that was a straight line between the school and her home. He said, "She had on a red hood and at times was on a run…I saw no one else near her," according to the *Watertown Re-Union*. However, Fuller admitted his view was somewhat obscured by the "knolls and hollows in the field" (and the fact that it was just starting to get dark out), but he was certain he hadn't heard anything suspicious. He was the last person known to have seen Sarah Conklin alive.

Sarah was born Sarah Polley in Massena, New York, and was given up for adoption to distant relatives, Mr. and Mrs. Alvin Conklin of Rutland. The day the loving couple carried their beautiful baby girl across the threshold

Courtesy of the author.

of their home was the happiest day of their lives. In stark contrast, on that frigid night in November 1875, as Mr. Conklin carried the body of his little girl across that same threshold, it was decidedly the worst day of his life. Details of the grim discovery were disclosed at the coroner's inquest at the Conklin residence on December 8. The fifty-one-year-old farmer said that, on the day Sarah was murdered, he had dropped her off at school between eight and nine that morning and started watching for her to return around three-fifty in the afternoon, as he went about his chores. After putting down hay and bedding for the horses and cleaning out the stalls, he returned to the house to "get a pail of swill" and again glanced in the direction that Sarah should be coming from to see if there was any sign of her. He then went to the cow stable and "turned the pail of swill into the trough for the hogs." Stepping behind the cows, he slid the window open and peeked out to see if his daughter was coming yet. Conklin saw his employee, William Fuller, in the hollow below the barn, but he didn't see Sarah. Walking back outside, he stood in front of the barn and heard a scream coming from the direction

of the schoolhouse. He continued listening for a minute, but heard nothing more and thought it was likely just children still playing at the school; yet something deep inside told him it might be Sarah. Becoming uneasy and concerned that his daughter might catch cold if she didn't get home soon, Conklin hitched up his horse and buggy and set out to find her; he couldn't remember if she was dressed warm enough for the weather—and he needed to be sure the scream he heard hadn't been Sarah's.

After driving to the teacher's house on Middle Road and learning that Sarah was not there and that her teacher's mother saw Sarah enter the woods right after school, Conklin hurried home to see if she had returned yet. His housemate, Mr. Gibson, said she had not. This meant Sarah had to be lost in the woods, in the dark, alone, and it was freezing out. Gibson and Conklin lit their lanterns and headed toward the woods. When Sarah wasn't found on the first search, Conklin sent Gibson to get more manpower. Meanwhile, Conklin found the tracks where Sarah first headed into the woods and began to follow them, spotty as they were. Finally, at about 5:30 p.m., he came upon a spot where he later surmised she must have first lay, for the ground seemed to be in "disarrangement," and then he saw her.

According to the transcript of the inquest, Conklin said:

> *There I circled again about where she* [must have] *stopped to spit blood; then I followed till I came to the two trees close together with blood on them; there again I lost her track, as I did not know which side of the tree she had taken; I looked up and saw Sarah lying on the ground; (here witness melted to tears). I went direct to her; I took her up and saw she was not stiff; her tongue protruded and her teeth were closed through her tongue; I felt of her hands to see if they were frozen; they were both frozen solid nearly to the wrist; I took my overcoat off and wrapped it around her, putting her hands inside; I felt of her feet to see if they were frozen; I found them warm or not frozen; I then went to rubbing her face and forehead; I found her nose and chin frozen; I looked up to see if Mr. Gibson and Mr. Humphrey were coming; I saw them nearly at the north end of the land leading from Mr. H's barn with a light; I halloed* [sic]*, and I think they answered; I waited a few seconds and halloed again that I had found her; they came to where I was; we took the body and fetched it to the house…I called for Samuel Warner and asked him to come to me quick; he met us, took Sarah in his*

arms; I think he carried her alone a little ways; then Mr. Gibson and others took and helped him into the house; then we put her feet into warm water and her hands into cold water; we rubbed and put alcohol on her face and body, rubbing thoroughly as we could.

Amid the frantic, futile efforts to revive the girl, one of the gentlemen sent for Mrs. Isham and Mrs. Humphrey, while a boy was sent in search of Dr. Stevens of South Rutland, who, along with Mrs. Humphrey, arrived shortly thereafter. Describing the condition of his daughter's body and clothing, Conklin said when he came upon her in the woods, one mitten was near her feet, and the other was found some distance away. Sarah was lying with her face in the snow and her arms at her side. Her red-hooded cape was "wadded up under her right arm," the button hole was torn out on one side of her drawers and her bonnet "seemed crowded back on her head." But it wasn't until they took the scarf off at the house that they found marks on her neck. The scarf, Conklin said, was "wound three times around her neck" so tightly that they could barely get their fingers under it to loosen it, but the ends were not tied together. Although they could find no pulse, the men were undeterred in their hourlong attempt to resuscitate the child. But nothing could bring her back. Sarah was dead.

Around 9:00 or 10:00 p.m. that evening, Conklin, Gibson, Humphrey, Samuel Warner and Dr. Stevens all returned to the scene of the apparent crime under the light of lanterns. They were searching for signs of a struggle or fall, but all they found in the darkness, according to Conklin, was a small stick a little larger than one inch in diameter with two knots in it. The next day, several men, including Conklin, returned again to the scene—this time finding another set of Sarah's tracks and more blood on another tree. The day after that, they again returned with even more neighbors to "look the ground over to see if [they] could make any new discovery." By then, the crime scene had been well-trampled and contaminated. Nevertheless, when the coroner and chief of police arrived from Watertown on December 2, yet another trek to the spot where Sarah's body was found was in order. This time, Stillman Woods and Samuel Warner found a suspicious set of footprints just outside the tree line and followed them into the woods, where they ultimately led to the crime scene. Returning to the edge of the woods, the men then followed the tracks to where they were believed to have

originated from, tracing them "step by step towards Mr. Humphrey's. They led directly to his barnyard." *Finally*, a break in the case.

Conklin told Coroner L.F. Phillips, who was conducting the inquiry:

> *Then I went to Mr. Humphrey's house and called for him; he was eating his dinner; he came into the sitting room, and I told him that I wanted him to go with me; in the meantime, I whispered to Jennie Humphrey and told her to keep watch of Frank* [Ruttan]*; then I asked if Uncle Riley was there; they said yes…at that time the Coroner came in; I spoke to Riley about watching Frank for a while; and he stopped and seemed to think. He said, "I don't know, but I can enlighten you a little." He said that on the day of the murder, Frank was absent about an hour he should judge… he (Riley) went into the house about ten minutes to four o'clock on that evening…he said the boy was missing from that* [time] *to five o'clock…*

Bingo. According to Riley, he hollered loudly to farmhand Frank Ruttan several times between 4 and 5 p.m., but to no avail. When the sixteen-year-old boy finally returned to his post, he told Riley he had been "up to feed the pigs and turkeys." Conklin told the coroner that he "fitted Frank's boot in several of the tracks, and it fitted perfectly;" but this was three days after the crime. The weather conditions may have altered the footprints, not to mention the heavy foot traffic from searchers and curiosity seekers. Still, Conklin became convinced, as did others, that Frank Ruttan had killed the girl, even though he was unaware of any problems between his daughter and the boy. But that would soon change, when he learned that there were, indeed, ill feelings between Sarah and Frank. Therefore, the prime suspect had the means (stick with Sarah's blood on it), the motive (ill feelings between them) and the opportunity (missing in action from his farm duties) to commit the heinous crime. It wasn't looking good for a young man with a tainted past.

According to "The Rutland Murder" in the *Watertown Re-Union* of December 9, 1875, Frank was the illegitimate son born seventeen years earlier to a young domestic named Emily Ruttan and Watertown barber George Bromley. Mrs. Bromley took Emily and her newborn in; and when Emily left baby Frank in the care of Mrs. Bromley the following summer and never returned to get him, Mrs. Bromley did her best to raise the bastard

Sketch of Frank Ruttan from the *Watertown Re-Union*, 1876. *Printed with permission from the* Watertown Daily Times.

child her husband had fathered. But then Mr. Bromley died when Frank was five years old, leaving a wife and six children. A year later, destitute and unable to feed any extra mouths, Mrs. Bromley decided to send Frank to the Jefferson County Orphan's Asylum, where she occasionally visited him. She told *Re-Union* reporters, "Afterwards someone took him away, and Mrs. Cory told her that a farmer living in Rutland had adopted him." That farmer was Henry Humphrey, and he adopted Ruttan when the boy was about twelve years old. Years later when Mrs. Bromley saw him on the street, he didn't remember her. He, therefore, never knew his parents or relatives, and although he had some respectable family members who would be saddened by his plight, his mother "had a very bad name," according to Mrs. Bromley; and one uncle on his mother's side had been sent to the state prison, while another younger uncle had been sent to a house of refuge. Frank Ruttan didn't stand a chance. According to the paper, "It was generally conceded that had not Ruttan been arrested and taken from the neighborhood when he was, he would never have been taken away alive. The younger people

who knew both the deceased and Ruttan were very bitter against Ruttan. At first no one thought of murder, but now scarcely anyone in Rutland believes otherwise than that Frank Ruttan murdered Sarah Conklin." And the postmortem examination seemed to indicate they were right, at least in as far as the death being a murder and not a freak, tragic accident.

The *Re-Union* on December 9 said:

> *In the minds of the medical gentlemen who made the* postmortem *examination yesterday, there is no doubt at all but the girl was brutally murdered. They think that she was first struck the two blows spoken of, and that then the murderer, finding his work not quite complete, finished it by strangling her to death with her scarf. The marks on the neck, and the lungs being gorged with blood, are evidences too plain to be mistaken that the poor child died by strangulation. Neither of the blows upon her head and face would have produced death. Her tongue, when she was first found, was protruding from her mouth, which is another evidence of strangulation.*

More specifically, the medical examiners, Drs. Trowbridge, H.M. Stevens and R.A. Stevens, found that the bone on the outer edge of the upper right eyelid had been crushed in a severe downward blow, obvious lines were found around her neck along with discoloration indicative of strangulation, finger nail scratches covered her left and right hands and wrists, as if someone had dug into them and held on tightly, her face was considerably swollen, and her lungs were profusely engorged with blood. The theory, before Ruttan gave a sworn statement, was that the boy saw Sarah leaving school that fateful day from the loft of the barn at Humphrey's, which commanded a view of the school and the woods nearby. It was supposed that he decided then and there to corner her and pay her back for speaking poorly of him.

The *Watertown Re-Union* said:

> *It appears that about a year ago, he sought to ravish the girl Sarah Conklin, but was repulsed. It is claimed that he also made a similar attempt upon the person of a little girl of Mr. Humphrey's. These girls, when in company, used to shame young Ruttan, and his anger was fiercely kindled against them. The story of his attempts had got abroad, and the boy frequently threatened to punish the girls for their taunts and scorn of him. One day*

he saw [Sarah] *at dinner and he said to a hired man on the place that he wished it was arsenic that she was eating. He is now said by the whole neighborhood to be a very sulky and vicious boy. He had frequently made threats of personal violence towards the girls.*

For these transgressions, Mr. Humphrey gave Ruttan "very severe thrashings, and threatened him that if ever he caught him at such attempts again, he would thrash him within inches of his life." Thus, Ruttan had another motive: the need to make sure that Sarah would never implicate him, or else Humphrey would make good on his vow to thrash him within inches of his life. In other words, once he decided to lie in wait for his young victim, he crossed a line that left him with no choice but to permanently silence Sarah Conklin or face "the wrath of Mr. H." The medical examiners believed that Sarah had been knocked down by an initial blow to the head, followed by a stronger blow that broke her cheek bone. Rising from the ground, she may have then spit the blood out of her mouth, as the crime scene seemed to indicate. Then, as Ruttan turned to go, Sarah struggled to her feet and passed between two trees, leaving more blood on them. The killer's footprints found at the scene indicated that he turned around, probably when he realized she had gotten up, and he returned to finish the job, strangling her with her own scarf. The medical examiners concluded that she had not been raped, but the torn button hole on her drawers suggested that Ruttan may have attempted to ravish her. According to the *Ogdensburg Daily Journal* of December 10, 1875, the jury from the coroner's inquest returned a verdict of "death from blows on the head from a club, and strangulation inflicted by one Frank Ruttan, on Tuesday, 30th day of November, with the premeditated design of effecting the death of the deceased." Frank Ruttan would be charged with murder in the first degree.

While in jail in Watertown awaiting trial, Ruttan made a confession in December 1875, which was kept hush-hush—at least until the press got wind of it in February 1876. First, the *Journal & Republican* said, "Efforts are being made to keep the confession secret." Then, the *Daily Journal* chimed in, saying, "The *Watertown Times* is roasting the persons who have received the confession of Frank Ruttan who murdered Sarah Conklin, and are keeping it to themselves. If their object is to make money out of their knowledge of the young wretch's crime, they deserve to be roasted." The confession was

made to a police officer, Miles Guest, the arresting officer who took Ruttan to jail. He said he had spoken to the boy on the day of his arrest and again on December 4, when he took him to Hart's Photography Gallery to have his picture taken. He said the boy offered to write out his confession, if Guest would provide him with paper, which the officer did. On December 10 or 11, Guest received the confession, which simply said:

> *December 9, 1875*
> *She called Me a Fool and i thought i would pay her for it. And i saw her coming From school and i run acrossed And she started to run And i throw a stick and hit her side the head. [sic]*
> *Frank Rutan [*sic]

Two months later, a more detailed second confession was made to Deputy Sheriff Babbitt. The following verbatim admission of guilt was quickly printed in the *Watertown Times* and the *Re-Union* in its entirety—and it was just as quickly rejected for its lies:

> *About a week before John Allen went away, he came to town and got a pint of whiskey, and left some there in the bottle when he went away. What was left in the bottle the day of the murder, I drank. Bertie Van Slyck told me that she (Sarah Conkling) [sic] had been calling me names. He told me the next night after John Allen went away. I stood in the alley way of the barn after throwing down the hay and looked out. I saw her near the barn by the school house. She was not in the lot. I went out the alley door and under the bridge. I went right close to the orchard fence and came back the same way. She got into the woods before I did. I asked her what she had been saying such things about me for. She didn't make any reply, but started to run. I ran after her with a stick in my hand. I don't know whether it was the stick shown at the coroner's inquest or not, for I didn't see that, but the one I had was a good, solid maple stick with a knot on it. I was about five or six feet from her when I threw it. I hit her on the right-hand side of the head. She dropped where she stood, and lay. She began to shake, and then got up and staggered along. Then I went to her again and tightened the scarf on her neck. She kicked, and tried to untie the scarf. I didn't mean to kill her when I hit her with the club, but she looked so that I was afraid she would*

go home and tell of me, and they would do something to me, and so I went back and killed her. I didn't stay more than five minutes after I tightened the scarf. I fed the turkeys before I left the barn. I shut the grain barn door, but didn't fasten it. I had on a coat over my frock. I didn't get any blood on me. I was scared about what I had done that night after I got back to the barn.

First of all, John Allen told the *Watertown Morning Despatch* that he never had any liquor with Ruttan at Mr. Humphrey's, and that if he had left a pint of liquor when he left there two weeks before the murder, anyone who knew Ruttan knew that the liquor would never last a full two weeks. Secondly, the confession contradicted the boy's earlier statements in which he said he killed her with a blow to the head and didn't strangle her. The *Watertown Re-Union* of May 18, 1876, took special issue with how the scarf was found wrapped around the girl's neck, reminding readers of earlier statements made regarding same:

The little fiend then went to her, held her down to the ground and choked her until she was quiet, and then drew her scarf about her neck as tight as he could, and tied it in a hard knot! *He then left her, and followed his track back, as the theory of the prosecution claimed, part of the way walking on his heels and part of the way on his toes, as the tracks indicated…If the person who* cut the scarf from the girl's neck after she was carried home, and after nearly all her clothing had been removed and efforts were being made to restore her life, will recall that fact, and the effort to get it off which resulted in cutting, he will remember it was *tied in a hard knot.* The liquor is a pure lie. This is one of the most atrocious murders ever known, and we only regret that the cold-blooded villain still breathes but will not tell the truth about his horrible crime.*

In defense of Ruttan, Dr. H. M. Stevens said he had been with Mr. Conklin and the others when they attempted to fit Ruttan's boots into the footprints in the snow several days after the murder, and he "thought it was not an accurate fit," according to his sworn testimony at the trial. He said the shank of the boot appeared longer than the footprint. To make matters worse, Sarah's teacher had taken thirteen of her students to the scene of the crime *the day after the murder*, and the oldest boy in the group was fifteen years old, meaning that the footprint that seemed (to Dr. Stevens, at least) to

be smaller than Ruttan's could well have been the student's footprint rather than the damning evidence needed to prove Ruttan's guilt. Another young man who visited the scene of the crime the morning after the murder when Messrs. Warner and Conklin were there said that he saw no club or stick that day. A.W. Hardy said that it was not until two days after the murder that he first saw an alleged assault weapon. It was a stick his brother found in the woods and was carrying toward Conklin's house. It was about twenty inches long, partly rotted—it probably would have crumbled with the slightest impact—and there was a little spot of reddish-brown on it, in an indentation in the wood. Hardy said he was certain the reddish-brown coloring was from natural mold and not blood. The testimony of these men and others made the jury's job more difficult. Had Ruttan been set up? Had evidence been tampered with? It certainly seemed possible. Then why would Frank Ruttan confess to such a heinous act? In a word, intimidation.

It was disclosed during the trial that Mr. Conklin, the grieving father of the victim, had coerced a confession out of the boy by what some would consider strong-arm tactics. You can't really blame him, after what he had just been through—seeing his little girl laid to rest—but his actions could have meant the difference between charging Ruttan with first-degree murder or second-degree murder—life in prison without parole or the death penalty. Hiram Hungerford told the court that he went to the jail shortly after Ruttan's arrest with Mr. Conklin, Mr. Penniman and a Mr. Kitts to talk to the prisoner. After careful consideration, the judge allowed Conklin's statements to Ruttan to be admissible in court.

According to Hungerford:

> *The prisoner was standing in the corridor; Mr. Conklin said to the boy, "You had better confess, for we have the evidence to prove you guilty;" then he said, "I guess we may as well hang you now as any time," and looked up;* Guest [the police officer who arrested Ruttan] *said, "Hold on, that won't do." Tears came into the boy's eyes; that was the only time I saw him show emotion; Conklin told him he'd better confess, that he had the evidence to convict him.*

W.M. Penniman's sworn testimony corroborated Hungerford's story. He said he went to the jail with Conklin, Hungerford and Kitts four days after

Postcard of courthouse in Watertown, New York. *Copyright 1905 by the Rotograph Company.*

the murder, and that Conklin told Ruttan he'd better confess and mentioned hanging him. He, too, said the boy began to cry at the threat. Mr. Kitts was then questioned in court regarding the incident. He said that Conklin said, "Here's a good place to hang him, better hang him up here," and he agreed with Hungerford that Conklin told the boy he had evidence to hang him.

On Saturday, May 6, 1876, Frank Ruttan was found guilty of murder in the second degree. When Judge Merwin asked if he had anything to say before his sentence was imposed, he looked down, and his lawyer, Mr. O'Brien, replied, "He don't wish to say anything."

With that, Judge Merwin said:

> *The verdict of the jury in this case indicates that they were satisfied that you killed this girl, and it is a terrible matter to contemplate that a boy of your age should have had the hardihood to accomplish a purpose of this kind. And it is certainly a lesson to all who are evilly disposed that should come home with a great deal of force. What your motives could have been we can only imagine, because there is no adequate motive that appears in this case. The motive must have rested in your heart and certainly could not have been more evil. In the place where you are to be sent, you will be kept at labor. You will have time to contemplate and review your action here, and it is the desire of the court that you should do so, and certainly to shape your thoughts and feelings in such a way that you may grow up a better man than you are a boy. There is certainly opportunity, and will be opportunity, no doubt, for you to improve and to be educated to some extent, so that your intellectual powers may be more or less developed. How much of happiness there may be for you in this world is a matter of doubt. You have by your actions brought yourself to this point. The sentence of the law is that you be imprisoned at the State prison at Auburn at hard labor during the period of your natural life.*

The *Watertown Re-Union* of May 11, 1876, said that Ruttan handled his fate with the same apparent indifference as he had displayed before he was sentenced. It also said that, when asked what he thought of his sentence, "he hung his head like a roguish school boy, and half smiling replied, 'I don't know.'" The paper, in its final word on the matter, said, "He will be taken to Auburn probably by the middle of the week. And how many people, in ten years' time, will remember Frank Ruttan?"

CHAPTER 5

GEORGE POWELL'S PROBLEM WITH WOMEN

STERLINGVILLE, 1876

On a chilly afternoon in March 1876, Julia Powell came in from outside to remind her hired girl, Barbara Zaphf, to add carrots to the butter they were churning to give it color. Then, according to Zaphf, she walked back outside and was never seen alive again. Her body was found in a three-foot-deep creek behind her home ten minutes later, and the coroner's official stance was that it was a "voluntary drowning." But the public outcry and rumors of foul play that ensued quickly prompted District Attorney Watson M. Rogers to undertake his own investigation—an investigation that proved to be stranger than fiction.

According to the *Watertown Re-Union* of March 16, 1876, Rogers, Officer William McCutchin and a representative of the *Despatch* "proceeded to the scene of the tragedy, about two miles west of Sterlingville, and found that the funeral ceremony had just been performed, and the body still remained in the house, the intention being to remove the body to Martinsburg, Lewis County, on Monday." Many friends and relatives of both Mr. and Mrs. Powell were there at the time, so the investigators were able to press those closest to the deceased for more details. But first, they visited the scene of the tragedy, aided by a few "who were in a position to give an explanation of the finding of the body and the place where the unfortunate woman is supposed to have entered the water." They found that the door leading from the rear of the house was "exactly opposite" the location of where the last footprint

leading into the creek was found and that a person could see the trail to the creek "in a straight line," if they were looking out the back door. The trail led downhill approximately 27.5 feet to the shoreline. After looking over the rest of the property, which consisted of the home, an icehouse, a large barn and two sheds, the investigators questioned those present for a half hour. Only at that point did George Powell, the deceased's husband, finally approach them, after taking his horse from the barn to the creek for water. The news article stated that he appeared "perfectly unconcerned" and did not look like a man who had just lost his wife. He became quite agitated, however, when asked why he didn't attempt to search for his wife in the creek, when he knew she must have just barely gone into it (he had seen her only ten minutes before in the house). Why didn't he assist the neighbor he

Courtesy of the author.

summoned to pull his wife's body from the creek, and why was he unable to explain the marks found all over his wife's body that indicated she had been beaten? All he would say in response was, "I must take this horse to the barn, or he will catch cold."

The investigating party then went back inside the house to continue the discussion. They learned that Julia Powell had been confined to the house and was very ill for about two months before her death. Mr. Powell's first wife, from whom he was divorced, lived in Lewis County. The hired girl was sixteen years old and had lived with the couple for just four weeks, along with a hired boy named Eugene Willard, who was twelve years old and had only been hired three or four days before the tragedy. The nearest neighbor was a farmer named Watt Slaid, who lived on the other side of the road forty-six yards south of the Powells. For some reason, when Powell set out to find someone to pull his wife's body from the creek so that he wouldn't have to, he went instead to the home of Mr. Converse who lived twice the distance of Slaid—even though time was of the essence, if they were to pull her from the creek and successfully revive her. Investigators viewed the body and found there to numerous marks indicative of a recent beating with a rod. She bore six contusions on one arm, four on the other and one each on her shoulder, neck, back, arm and hand. Yet, no postmortem exam was held prior to the district attorney's visit, and Mr. Powell was not required to provide a sworn statement to the coroner's jury during the initial inquest—a point that didn't sit well with District Attorney Rogers. Had he provided a sworn statement, he would have become a person of interest in any rational man's mind.

Powell told Rogers that on the day of the tragedy, he and Julia Powell arose earlier than usual. Julia appeared to be more cheerful and in better health than she had been since the start of her sickness, and she was eager to have some butter churned. Powell helped her carry the cream out of the buttery and place it near the stove, so it could be warmed up and softened for the process. He said his wife helped the hired girl prepare breakfast—which she hadn't felt well enough to do in a while—and that he went to the barn after eating to do his chores. Between 8:00 and 9:00 a.m., he went a third of a mile down the road to his father's house but insisted he hurried back, "as fast as [he] could," estimating he had been gone only a half hour. When he returned, Powell said he went inside and

George Powell's Problem with Women

Photograph by American Colony. *From the Library of Congress Prints and Photographs Division.*

looked in the bedroom for Julia but saw that she wasn't there, so he asked the girl, Barbara, where his wife was. Barbara said Julia had gone to the barn ten minutes before he returned and that she hadn't seen her since. So supposedly the two of them—the girl and Mr. Powell—began searching for and calling to her.

After checking the barn, the icehouse and the wood house near the woods, he headed down the trail to the creek. There, near the creek, he said he saw the footprints of a woman's shoes in the snow leading directly into the water and "was satisfied she had drowned herself." *Satisfied she had drowned herself?* Is that how an innocent man would react upon realizing his wife had just died tragically? He then turned around and started for Mr. Converse's house, about one hundred yards away and saw that his hired boy had reached his neighbor before him. Powell asked Converse to help him, but when they got halfway between his house and the creek, he stopped and waited at the icehouse as his neighbor continued on to the creek with a rod. Converse poked the rod around in the frigid water until he found the body, about twenty-five feet from the shore. Powell could see a bit of his wife's body, fully clothed in the brown dress she had last been seen

wearing, as it floated to the surface. But he could not bring himself to help his neighbor drag the body to shore. Instead, he opted to wait for others to arrive and let them do the gloomy deed. This bizarre version of events certainly left the district attorney and the officer investigating Julia Powell's death eager to cross-examine the people involved that morning, beginning with George Powell.

The interview went as follows:

Q: When you concluded she was in the creek, why did you not look for her? Life may not have been extinct.

A: I wanted some person else to do it to make everything straight; if she had been on the surface alive and struggling, I could have gone and brought her out, BUT I COULD NOT SEE HER.

Q: She could only have been in the water a short time; she only went out ten minutes before you arrived?

A: But I went to the woods looking for her. The wood mill is there.

Q: How far are the woods?

A: About 200 rods.

Q: Why did you suppose she had walked so far when she was so weak and when the mill was not working?

A: I don't know, unless it was because she went there when we were at work and she was well enough.

Q: Well, why did you not help Mr. Converse take her out of the water, instead of making her wait until other help arrived?

A: Because I am very nervous and cannot bear to look upon a corpse, and besides, I wanted somebody else to do it so that I should be cleared. Mr. Converse said I acted right in doing as I did. I faint very easily; if a stick falls in the barn, it frightens me very much.

Q: What have you done with the shotgun and ramrod which was in your bedroom before your wife was drowned?

A: There never was one in my bedroom here, as I have not owned one in twelve years, and to my knowledge, there has not been one in the house.

Q: Mr. Powell, supposed I should prove by several that there was a shotgun in your bedroom during your wife's illness and that it stood against the bureau?

A: (Excitedly) I can impeach any man who will swear there was.

Q: Do you mean to say that, as a man, you have not sufficient courage to rescue or assist in rescuing from the water the body of the one who was your wife?

A: I could not do it. I also was of the opinion that when a dead body was found it should not be disturbed, and, as I could not see my wife, I supposed she was dead; but a coroner should be called and arrive before it was touched. Mr. Converse said I did right.

Q: Had you ever had any reason from your own observations to believe your wife was very nervous, or did she ever show any symptoms of insanity?

A: No, but Dr. Wauful says she was a very nervous person.

Q: Do you *think she was?*

A: I suppose so; the Doctor says so.

Q: Do you know it yourself?

A: I am not a Doctor. (He reiterated this last answer every time the question was put.)

Q: Have you always lived happily with your wife?

A: Have been married about fourteen months and have always lived happily.

Q: Can you give any reason why she should have drowned herself?

A: I cannot, unless she was crazy.

The next individual to be questioned was Barbara Zaphf, who said that, in her four weeks working for the Powells, they always seemed to get along well together. She said that when Powell went to his father's house, "Mrs. P" went out the back door and was gone about five minutes. She came back in and reminded Barbara to put carrots in the butter for coloring, and then she went back out the back door. Ten minutes later, "Mr. P" returned to find his wife missing. The girl said that she called to Mrs. Powell shortly after she left the second time, and getting no response, she went to the barn and looked for her. When she returned to the house and looked out the window, she saw Mr. Powell returning and decided to stop looking until he returned and she could tell him what was going on. The hired boy provided a similar story—all pointing the finger at an alleged suicide. But Mrs. Rees, the sister of Mrs. Powell, told the district attorney that her sister had always claimed to be very happily married in her letters, never giving any indication that she was suicidal. And the marks found on Mrs. Powell's body pointed to foul play; she didn't beat her own body with a rod or switch before entering the water.

The *Re-Union* summed it up well, saying:

> *It certainly was a great mistake on the part of the coroner's jury not to have had the husband sworn. The neighbors think so, and they also claim that the bureau was locked within fifteen minutes after the body was brought to the house and say that if she did destroy herself, that she left a letter telling the reason. These very people who state that the bureau was locked at the time above mentioned were the ones who assisted in the first part of the last sad duties and also remained until after the inquest. There are also two persons who distinctly remember seeing the shotgun in the bedroom and who say that as soon as the marks were discovered on the body, they immediately thought of the ram-rod of the gun; but it will be seen he denies ever having a gun in the house. He also denied having any knowledge whatever of the marks on the body, had never noticed any, and could not account for any…There appears to be a mystery about the affair which may or may not be solved.*

Suffice it to say, the coroner's inquest was a travesty. And because it was, there was nothing on which to convict George Powell. He may as well have been a saint in the eyes of the law, for he could not be made to pay the price for a death that many who knew him were certain he was somehow responsible for. But Powell was no saint. Less than a year after his wife's untimely death, George Powell and Dr. George D. Hewitt of Carthage were both arrested by Carthage chief of police Budd and Officer Peter Lyman, respectively, on warrants charging Hewitt with *producing* an abortion on a young girl named Ella Allen of Carthage and Powell with *advising* the abortion.

According to the *Re-Union* of January 18, 1877:

> *The girl, Ella Allen, on whose complaint for producing abortion, Dr. Hewitt, of Carthage, and George Powell, of Sterlingville, were arrested on Tuesday last, made complaint in her affidavit, that on or about the 15 day of October, 1876, George Powell had carnal intercourse with her, and also on several occasions subsequently, by which she became pregnant. That on or about the 15th day of December, Powell learned of the fact and proposed to her to have an abortion produced, stating that he would go to Carthage, see Dr. Hewitt, and make arrangements with him for that purpose; that*

George Powell's Problem with Women

Courtesy of the author.

Powell did afterwards go to Carthage, and on his return claimed to have made the proposed arrangements, and provided her with money to pay her board and other expenses while in Carthage, where she went, and procured board and room at the boarding house of Solon Birmingham; that she was visited by Dr. Hewitt on the 29th day of December at her room, at which time he performed an abortion upon her with an instrument with intent to produce miscarriage, and that in consequence of the operation, she was on the fifth day of January delivered of a premature child then dead.

Less than seven months after his wife's tragic death under highly suspicious circumstances, George Powell was having intimate relations with the hired help. Ella Allen started working for Powell as a servant girl in the fall of 1876, which makes one wonder what became of Barbara Zaphf, the girl who lived with the Powells at the time of Mrs. Powell's drowning earlier that year. It seems George Powell held little regard for any female, be it his wife or servants. Had it not been for the young woman becoming seriously ill following the abortion and requiring the services of another physician when

Hewitt could not be found, Powell would only have been remembered for a possible connection to the death of his beaten and drowned wife. With the latest revelation, any delusions of his respectability that some previously held for the man were quickly dispelled. Eighteen-year-old Allen insisted she had been "strictly virtuous up to the time of her meeting George Powell."

The paper continued:

> It appears that after Dr. Hewitt's first visit, he continued to attend her up to the 5th inst., visiting her usually as often as twice a day. On the evening of the 5th, although he had already visited his patient twice that day, he was again sent for as she was unusually ill, but the messenger was unable to find him; consequently Dr. Ferguson was called in, after which the latter continued to visit her. His suspicions being aroused from the girl's condition, he conferred with Judge Emmes, who visited the girl, and she made a clean breast of the whole matter, and made affidavit before him as above.

The abortion left Miss Allen so devastated that she wanted to kill herself. After attempting to get someone to procure arsenic for her, Dr. Ferguson removed her from the boardinghouse and took her in under his own roof where he could keep a close eye on her. Hewitt and Powell were taken before police justice George O'Leary, waived examination and were committed. Both men were indicted by the grand jury, were arraigned and pleaded not guilty. Hewitt was released on $5,000 bail; and Powell's bail was set at $2,000. Apparently, Powell didn't show up at his trial. The *Re-Union* of February 28, 1878, said that in the case of the *People v. George Powell*, the defendant neither answered nor appeared when called to the bench, so his bondsmen, Jonathan Powell and Edward Kohler, were ordered to produce him. When they were unable to do so, "it was ordered, on motion of the District Attorney, that the recognizance be forfeited and prosecuted." Hewitt fared better. According to the May 31, 1877, *Re-Union*, the jury returned a verdict of not guilty in the case of the *People v. George Hewitt*. Although I could find no further mention of the prosecution of George Powell for not appearing at his trial, if Hewitt was cleared, there's a good chance that Powell walked on this one, as well.

CHAPTER 6

THE SPINELESS SHOOTING OF MARY WARD

LERAY, 1893

On Sunday, December 3, 1893, town of LeRay farmer Henry Miles shot and killed Mary Ward with a single, cowardly, pitiless bullet to her back. Ward was a woman with whom he had recently lived "on terms of criminal intimacy," according to papers of the time. It didn't take long to determine what led to the atrocity, for Miles assisted a neighbor in carrying the body back into the house before heading to Evans Mills to turn himself in. From the beginning, he told the same story over and over again, unashamedly. Life behind bars or the death penalty would be preferable, as he had been wronged by the only woman he trusted. After all, he told neighbor I. M. Carpenter, who was first at the scene, "they could only 'electricity' him." At the time, he didn't care if he paid the ultimate penalty.

Henry Miles was the fifty-four-year-old son of Andrew Miles, known around the community for his involvement in a number of lawsuits. Two of Henry's brothers, Andrew and Baker, lived in the Philadelphia, New York area, and one, an ex-con named Duane Miles, lived somewhere in Jefferson County, having recently been released from State Prison, where he served time for assaulting a little girl. Henry got along fine with Baker, saw little of Duane and couldn't stand Andrew. Throughout his life, Andrew always seemed to have it in for him. When the family patriarch began failing in health and going blind in 1888, Henry's parents and the "good" brother, Baker, traveled to Rochester, where Henry was then living, to convince

Courtesy of the author.

him to return home and claim his share of the family property. They also recommended that he remarry and settle down—again. A marriage to Jane Pelkey of Carthage, which produced two sons, had failed; as did a marriage to Emma Lawrence in Rochester, who left him and entered a "house of ill-fame." He then married a third woman named Anna Salder, who deserted him one day to also enter a house of ill repute. Yet, even with three failed marriages, on his family's advice, Henry placed an ad in the Rochester newspaper for another wife and/or housekeeper and received fifty responses. That's the way he rolled.

In the first week of January 1890, Mary A. Ward arrived from Rochester to meet Henry and decided right away that she wanted to marry him. But he declined, saying he didn't feel her health was good enough for the work of a farm wife. The following week, Mercy Ann Corp showed up at his door

and insisted he marry her, and he obliged. That relationship—his fourth marriage—ended due to domestic violence but not before producing a baby girl. District Attorney Kellogg said that Corp "had been turned into the street with her babe with not a cent to support her, and not a roof to shelter her." She moved to Watertown but never officially divorced Henry, although she was legally separated from him.

Kellogg later told the jury:

> *On the first day of November in that year, he did recover of his father's property, amounting in value to $5,000, consisting of a farm in the rich town of Philadelphia and the utensils and implements to carry it on… We shall show you that he came from Rochester to move upon that farm and to take possession thereof, bringing with him and introducing as his wife a woman* [Mercy Corp] *who shortly after left him with wounded heart and bruised limbs. We shall show you that shortly after, he traded the farm that he received of his father for a farm known as the McCrea farm, containing 111 acres; the last place in the town of LeRay, on the road from Evans Mills to Ox-Bow.*

At the time of the property trade, and as a condition of the purchase price of the McCrea farm, Henry had no choice but to execute a mortgage on the farm to his brother, Andrew. When Andrew foreclosed on the property, Henry knew he would lose his home and farm, unless he could convince someone to buy it *and* let him still live there. The answer seemed obvious: he would pay a visit to Rochester and see if Mary A. Ward was still available. She had shown an interest in marrying Henry, if ever his marriage to Mercy ended. And, as luck would have it, she had saved about $1,500 to someday put toward purchasing her own home.

Henry described the breakup of his marriage to Mercy Corp and the introduction of Mary A. Ward, a widow of about fifty, into the picture in his statement to the *Watertown Herald*, which was published in the December 9, 1893 edition:

> *When she arrived there, my wife and I were milking in the dooryard by the woods. She asked me if I had married yet, and I told her that I had and pointed out my wife to her. She then said I would never live with her*

[the wife] *and that I would want another wife. I merely laughed and said I thought not. "If you don't live with that woman, will you remember me," she asked; and I replied that I would. Mrs. Ward then came back to Philadelphia [N.Y.] and returned to Rochester. I lived with my wife until the following September, and then she went to Canada, where she remained four months. She then came back with her child, which was born during her absence. From Jan. 1, 1891, until September, she lived with me. She then went to Watertown to have me arrested on a charge of non-support. However, no warrant was issued, and I was not arrested.*

I now sold my household goods and started for Chicago. I remained there only two weeks, when the thought came to me that my brother might try to beat me out of my property, upon which he held a mortgage, and so I started for home. From Chicago, I went to Rochester, and there met the Ward woman again. I related the circumstances regarding the mortgage on my property to her [and] told her also that the farm contained 111 acres, valued at $45 to $50 an acre. The mortgage was for $3,100, and I told her that I thought I could get my neighbors not to bid on it, and if I succeeded in that, it could be purchased for about the value of the mortgage. She said she wanted a home, and I re-echoed her sentiments. An understanding was then reached between us, that in case the property could be purchased, she and I would always live together and own equal shares in the property, and to the one surviving, the estate should descend.

Hence, a fateful deal was struck with Anna Ward to buy the property and live with Henry Miles as his housekeeper and his intimate companion (since he was still legally married to Mercy Ann Corp). Anna had been married to Philip Ward, a war veteran, for ten years until his death in 1874, at which point she lived off of the twelve dollars per month she received as a soldier's widow, as well as her dressmaking business. According to the *Watertown Re-Union*, Ward was a "woman of fair and ordinary intelligence, comely in person, but irascible and exasperating in temper." The middle-aged woman was well proportioned and weighed 165 pounds. She had "a rich growth of dark hair, blue eyes, and the characteristic face of an Irish woman and was fairly good looking."

Miles insisted that things seemed to be going along fine with Mrs. Ward until a dispute on September 19, 1893, when James Casey came by to pay the

Courtesy of the author.

couple $332 for hay, and Mrs. Ward grabbed the check and refused to divide it with Henry. Justice of the Peace Fred E. Croissant testified that the couple had been before him that month to make their "understanding" official.

He said:

> *She was to pay him $300, and he was to go away. The agreement they had previously made was to the effect that they should share equally in the avails of the farm. I don't think anything was said in the agreement about what was to be done with the property after either of them died. I saw her snatch this paper from him. She afterwards made a complaint to me about an assault that he committed on her. He pleaded guilty, and I sentenced him to pay a fine of $10 or ten days in jail. I saw him after he came out of jail.*

In Miles's brief absence, Mrs. Ward wasted no time in hiring another man to work on the farm, and Miles was forced off the very property he

had tried so hard to hold onto. Renting a house across the road, he kept watch on the activities of Mrs. Ward, day and night, and was convinced that she was having "improper relations" with twenty-eight-year-old Richard Rusaw, the young man she had just hired. Miles also became convinced that Ward was trying to put poison in his food when she invited him for several meals, so he stopped eating there but occasionally accepted odd jobs around the farm for pay from Ward. His plans had all been turned upside down, when he was cast out of his own home by the very person he trusted to help him keep it.

The night before the murder, as Miles spied on the house in a snowstorm, he was sure he saw Mary and Rusaw in her room, so he went to the house at 3:30 a.m. and ordered Rusaw to leave. Rusaw begged to stay until morning, for he had nowhere else to go in such inclement weather, and he didn't realize he was dealing with a homicidal maniac. The next morning, Miles returned to the house at 7:30 a.m. in a highly agitated state.

His story, remarkably similar to that of the other witnesses, was as follows, according to the *Herald*:

> [Mrs. Ward] *told me that I had gotten through there and that she would not take me back. I said, "Mary, if you do not take me back, I will kill you," and at the same time, I told the young man to get out of the house, as I was going for my gun and that he had better move quick. I went across the road, then to my house; I took my breech-loading shotgun down from the wall where it was hanging and put two cartridges in it. After doing that, I drank a cup of tea, ate some crackers, filled my pipe and smoked it, and then looked out of the window to see if the young fellow had gone; I could not see him down the road. I then took my gun and mittens and walked leisurely over to Mrs. Ward's and went to the back kitchen door. I looked through a window and saw the hired man going out into the wood shed, and Mrs. Ward was just behind him. She told him to shut the outside wood shed door. I said, "Never mind, young fellow. Where is your hat?" He told me that it was none of my business. I then kicked the wood shed door open. Mary said, "Get out of here or I will have you arrested." I asked her if she wasn't ever going to give me back any of my property or else take me back. "No, I will never have you in the house again," she replied. "I will kill you if you don't, and I will be as good as my word," I retorted. She replied by*

saying, "You dare not touch me." I told her then that I didn't want to touch her nor harm her, but that she must do as she had agreed.

The hired man said, "Get out of here or I will stick you," but with what kind of an instrument, I know not, as I did not see any around. Upon hearing this from him, I quickly cocked my gun and fired into the wall. He ran, and I didn't see him again. I now spoke to Mary and asked her if I should kill her, or would she do as she had agreed. She replied by telling me to get out or she would have me arrested, and then she grabbed hold of the gun and tried to take it away from me, when I slapped her across the forehead or else across the ears. Then she ran out the doors, yelling with all her might. I called out to her not to run to the neighbors', but to stop, and if she didn't I would kill her. She sped on; I cocked the trigger to the empty barrel. It snapped. Then I cocked the other one, pulled the trigger and fired, and Mary fell.

Miles told of his actions as if he truly believed he was in the right—that she had been warned and didn't heed his warning, so he was justified in acting upon his threats toward her. When I.M. Carpenter was summoned to the scene, Miles and Carpenter carried the body into the house and lay it down on the bed "where he folded her arms nicely before leaving to give himself up to an officer." Carpenter said:

[Miles] folded her hands, closed her mouth, and kissed her several times. He was sobbing all the time. He said, "Mary, I killed you because I love you. You proved false and I couldn't stand it." He asked me to take him to the Mills [Evans Mills]. He said he wanted to give himself up, saying that he might harm somebody. He took me in the house and showed me some things that he desired his little girl to have. He wanted me to take him to Philadelphia so that he could kill his brother, Andrew, saying that Andrew had robbed him all his life and that he would fix him. He gave me the gun, but asked for it again, saying that I could have it, but he wanted to use it once more. I told him he didn't want it; he dropped his head and finally said that he was ready to go. We drove to the Mills in a buggy. I noticed that his face was very red. On the drive to Evans Mills he said he had watched the house all night and that he did not intend to kill her. I did not detect the smell of liquor on him and did not observe that he had a bottle of whiskey.

At the Mills we got a pair of [illegible] *and, in company with Constable Fredenberg, brought Miles to jail, arriving here about 1 p.m.*

From the moment Miles admitted to the Carpenters that he had killed Mary Ward, he spoke freely and unapologetically about his crime, assuring all who would listen that he wanted a speedy trial and didn't care to be alive any longer. Miles's dying father was spared news of his son's actions for fear that it would hasten his demise, and his mother became ill upon hearing of it. This deeply troubled the otherwise undemonstrative killer. But what troubled him far more was his brother's response when asked who was living on the farm now. It was, of all people, Richard Rusaw! The Frenchman that Miles despised, because he believed he was having relations with Mrs. Ward, was now living there on what Miles considered to still be *his* property. The revelation infuriated Miles beyond words, and he "flew into a frenzy and said that he was now sorry that he didn't follow Rusaw down the road that Sunday morning and kill him," according to the *Herald*.

Rusaw added additional details to Miles's story. He said Miles had been lurking around the outside of Mrs. Ward's home in the snowstorm, threatening his and Mrs. Ward's lives all night long. He came back over on Sunday morning, and when Rusaw saw that he had the shotgun, he escaped out of the back door. Miles, he said, smashed the door, accused Mrs. Ward of being intimate with Rusaw and begged her to take him back. Authorities believe he struck her over the head when she refused, because she had two deep cuts on each side of the scalp reaching to the bone.

Rusaw, according to the *Watertown Re-Union* of March 14, 1894, said:

I reside at Whitney's Corners; am 23 years old and my parents are dead. Mary A. Ward hired me to work for her on Sunday, November 19, just two weeks before the murder. When I went there, Mrs. Ward and I were the only occupants of the place. Miles was standing in the horse barn door. When Mrs. Ward and I drove up that Sunday, she spoke to him and asked him what he was doing there, saying that she didn't want him around. He asked for some grease for his boots, and she gave it to him. He said to her that she had got a hired man, and she made no reply. I next saw Miles the following Monday morning. He had a conversation with Mrs. Ward and said he wanted some potatoes. She told him to get the bags and she would

fill them. He called her a vile name, and she told him to get off the premises. He told her that she wanted to get that young fellow out, meaning me, and told me to get away or he would fix me so that I would. The next time I saw him was on Friday, Dec. 1, when Mrs. Ward came to Watertown to pay her interest. Miles was standing on the plaza of his house when I asked him which would go best, a cutter or a wagon. He replied neither one. He saw us drive away.

I went to bed at 9:15 the night before the murder and occupied the bedroom off the kitchen. About midnight I awoke and heard Miles say: "Mary, you told me if I ever caught you, I could kill you, but (with an oath) I won't do it." He then came over to my window and said: "Dick, how easy I could knock out a pane of glass and kill you right in bed!" He then went away but returned shortly afterwards and told me to get out. I told him I would in the morning. He accused me of having been in Mary's room. When he came around again early Sunday morning, I told him we would cut some bolts, which are used for the heads of cheese boxes. He asked how much Mrs. Ward would pay, and I told him 40 cents a cord. He said with an oath he would make her pay 50 cents. I asked him if I should go to his house or come back to Mrs. Ward's. He told me to come to his place and that he would kill me if I ever came back out there again. About 7 he came to the kitchen window and asked me if I was going to get out. I told him I was, and then Mrs. Ward came out in the kitchen where I was and told me to lock the door. At that, he burst the door open, and I ran out. Before that, Mrs. Ward said she would put a bullet in him if he didn't go away. He placed his face against the window and dared her to shoot, saying that he would go home and get his gun and kill us both. When Miles came back and broke in the house, I heard a scuffle and the explosion of a gun, followed by a scream. A moment later, I heard her say: "For God's sake, help me, Dick!" I looked back and saw Mrs. Ward running from the house and Miles following her. I heard the report of a gun again, and another scream, and that was all. I run down to Mr. Carpenter's.

A number of individuals at the trial testified that they had witnessed Miles's violent tendencies firsthand, like Will Youngs and Burt Haun, who were threatened with a pitchfork; Jacob Helmer, whom Miles threatened "to smash"; August Stoll and John Baller, who saw him threatening to kill

a man with a knife in Rochester; and Ele Sovey, who heard Miles threaten to kill his own dog and a neighbor boy during one of what he called "those spells." Perhaps one of the more damning recollections came from a Philadelphia, New York man named Fred Hart, who had known Henry Miles nearly all his life.

He said:

> *One day Henry came up to a ditch where I was working. He had his sleeves rolled up and was as calm as you and I are to-day. I said something about Andrew B. Miles. He became angry and said that all Andrew was after was law and to beat folks. Henry then said that if Andrew was here, he would cut out his heart and hang it on a stake.*

Miles's fourth wife, Mercy Corp, showed up in court as the defense opened. She had with her Henry's little girl, whom he held in his lap for the remainder of the last day of the trial. Their entrance resulted in the first show of emotion anyone had seen on Miles's face the entire trial.

The *Re-Union* said,

> *Just before Attorney Charles G. Porter arose to address the jury, a good-looking young woman entered the courtroom, leading a pretty girl of five summers. The woman was a decided brunette, had large, bright eyes, a clear complexion, and was neatly dressed in black.*
>
> *Miles' child had pretty rosy cheeks, large brown eyes, and smilingly ran up to the prisoner, jumped into his arms and kissed him. It was his own offspring, and the woman was formerly his wife…The prisoner and the woman did not speak, but Miles held the child in his arms and sobbed bitterly all the afternoon.*

Even though the defense tried to show that Miles's temperament was the result of several head injuries suffered early in his life, exacerbated by the trials and tribulations of his later years, the jury needed only two and a half hours to reach a guilty verdict: murder in the first degree. On March 13, 1894, Miles was brought before Justice Peter B. McLennan and, before an audience of some two thousand people who had crowded into the courthouse and the walkway leading to the jail, he was sentenced to die in

Courtesy of the author.

the electric chair at the state prison in Auburn the week of April 22, 1894. When asked if he had anything he wanted to say before his sentence was read, he declined comment.

The judge, in his sentencing speech, said, in part:

> *The court believes you have had a fair and impartial trial…after, as I believe, considering it fairly, honestly, and conscientiously, the jury decided that you were guilty of the highest crime known to the law. They decided that you deliberately, and with premeditation intending so to do, took the life of Mrs. Ward. After hearing your history from your own lips, it is not a matter of much surprise that your career should have ended in that way. You seem to have had your hand raised against society and its laws almost since your boyhood. You seem to think you could maltreat the weak women at pleasure and will, seemingly becoming, as the years went on and on, more and more determined in your course to injure anyone who crossed your path. I only wonder that some such catastrophe had not happened long before.*
>
> *While we are sorry for you and sympathize with you in your trouble, we are also sorry for your victim and sympathize with her. Though perchance*

her life was a little stained by sin, yet so far as it appears, it may have been the result of your actions only. In all events, she came to her death by your deliberate act. The law is that for such crime, punishment must follow. The last words that I would say to you is that in the few weeks that remain to you, you think of brighter spots in your career, and give those sentiments and impulses that are pure the ascendency, so that you may be better prepared for your fate. You may rest assured that you must pay the penalty.

Miles showed no emotion and didn't even blink as the judge read his sentence. Perhaps it was shock or stunned silence, as the reality of his conviction set in. But he broke down on the way out of the courthouse. To his estranged wife, Mercy Corp, he left all of his money and asked that she deposit it in the Jefferson County Savings Bank in the name of his daughter. With only that loose end to tie up, he was ready to go and face his sentence. En route to Auburn, he said, "I won't ask for a new trial, but I suppose my lawyer will. If a new trial means imprisonment for life, I do not care for it. I would rather have things go on just as they are planned. I would rather die at the time set than spend the balance of my life in prison. It's been bad all the way through, and I do not fear death."

Early postcard of Auburn Prison, circa 1914. *Courtesy of the author.*

At Auburn, Miles became an exemplary inmate; and his death wish was soon rescinded. He decided that he wanted to live, after all. According to the *Re-Union* of November 10, 1894, the prison chaplain said that Miles "was a model prisoner and had lost all of his bravado and boasting that he was ready and wishing to die." Thus, Judge Wilbur F. Porter and the Reverend Francis A. Strough made an earnest appeal to Governor Flower on Miles's behalf on Thanksgiving Day, presenting the governor with a petition for the commutation of the sentence to life in prison, rather than the electric chair. Strough's plea was that the murder of Mrs. Ward was "the natural result of Miles' environment and early training, and that even Governor Flower or himself, if brought up under similar conditions, might have committed a like deed."

The governor was moved by the gentlemen's arguments, and in early December 1894, he agreed to commute the sentence, saying:

> *Taking into account Miles' low order of intellect, the great excitement under which he was laboring, and all other circumstances of the case, the*

Governor Roswell Flower. *From Emerson's* Our County and Its People *(1898).*

deliberation and premeditation necessary to constitute murder in the first degree do not seem so clearly established as to warrant the infliction of the death penalty. The case has naturally excited great interest in Jefferson County, where the homicide occurred, and there is a very general sentiment among all classes of people that life imprisonment will be a juster and wiser punishment; and upon a careful consideration of all the facts, I am fully convinced that justice will be best promoted by commuting the sentence.

Henry was relieved and expressed "profound gratefulness" to the governor for sparing his life. Nearly seven years later, Miles died in prison of "valvular disease of the heart" at the age of sixty-two. His remains were sent to Philadelphia for burial following funeral services at the Congregational church.

THE MARY CROUCH–MARY DALY DOUBLE HOMICIDE

SACKETS HARBOR, 1897

The criminal annals of Northern New York contain nothing in any manner paralleling the Sackets Harbor tragedy. As the rumors are sifted and facts brought to light, it is difficult to decide whether it was a deliberately planned murder or brought about by circumstances as yet unknown.
—Watertown Herald, *April 24, 1897*

About 2:45 a.m. on the morning of Friday, April 16, 1897, liveryman William Markham was unhitching a team of horses when the team that Private George F. Allen had hired some eight hours earlier came rushing into the yard without its driver. As Markham approached the carriage, he was horrified to see two lifeless female bodies hanging precariously out of the buggy—that of Mrs. Wilbur Crouch and her friend and coworker, Miss Mary Daly, to whom Allen was engaged to be married the very next day. "Save for a little spasmodic movement of the jaw in the case of Mrs. Crouch, life in both cases was extinct," said the *Watertown Herald* two days later.

And the *Watertown Re-Union*, in its first article regarding the case, said:

> *His* [Markham's] *blood was chilled as he saw that the carriage was occupied by the corpses of two women. One was the body of Mrs. Wilbur Crouch. It was on the left side of the buggy, most of her body being outside of the box and her head on the floor of the barn, the body between the*

Sketch of carriage carrying bodies from the *Watertown Re-Union*, 1897. *Printed with permission from the* Watertown Daily Times.

forward wheel and the dash. Her disheveled hair had trailed through the mud, and her face was covered thickly with mud, as if it had passed through the puddle of the roadway. Blood was oozing from a large wound on the head. The scalp had been peeled partly from one side of the head, as if by violent contact with a stone. The other woman was Mary Daley [sic]. She had sunk down into the bottom of the buggy box. Her clothes were badly burned, especially on the back, and the fire had eaten away part of the fabric of her corset. One of Mrs. Crouch's feet had been caught under the seat and that was what held her body in the position in which it had evidently been during a ride of several miles. The paint had been worn from the buggy wheel where it had come in contact with her body.

Forty-five minutes later, as authorities rushed to the bizarre murder scene at the livery, thirty-two-year-old Allen staggered into the Madison Barracks mess hall badly wounded. He was begging to be taken to the hospital. Over the course of the next six months, his version of the events that transpired

George Allen-Haynes. Sketch from the *Watertown Herald*, 1897. *Printed with permission from the* Watertown Daily Times.

that evening, while in the company of the two aforesaid lady friends, changed with such frequency that District Attorney V.K. Kellogg would remind a jury at Allen's trial, "the stories do not harmonize, and that is the way that criminals are always caught"—always. Nevertheless, Allen, a private in Company F with a dozen-some years of military service, maintained that the man who left him for dead and slaughtered the two women was Mrs. Crouch's former husband, Wilbur Crouch.

When questioned by Coroner Dick and Dr. Ware, Allen's original story—called an "incoherent utterance" by the *Watertown Re-Union* of April 21, 1897—was this:

> [Thursday] *night, about 8, I went to Thomas Jackson's livery stable and hired a team to take Mary Daley* [sic] *and Mrs. Crouch to the home of Mrs. Carr, Mrs. Crouch's mother. A soldier named Davis road to the barracks club with me, where we got some cigars. I told Davis that Crouch*

had seen me get the team and was watching me and would probably follow. I took the women in the carriage, and we went to the home of Mrs. Crouch's mother. I noticed a buggy on another road nearby as we were returning. We were about a quarter of a mile from Mrs. Carr's when we met a man in the road afoot. The man grabbed a line and stopped the team. I recognized him as Crouch. I was on the right, and Miss Daley was sitting on my lap, driving, while I had my arm around her. I tried to start the team, but Crouch hung on. I started to get out of the buggy. As I did so, Crouch hit me with a stone, which he held in his hand. I fell forward on the dashboard. I tried to make a bluff with a little 22 caliber revolver that I had and by accident it went off and shot me.

Mrs. Crouch exclaimed, "Oh, my God!" Then several shots were fired by the assailant. Miss Daley fell forward and then Mrs. Crouch fell, both on me, pinning me down in the buggy. It seemed to me that as many as 16 shots were fired. Crouch then got into the buggy and took the reins and drove to the Watertown road and up that road to the turn toward Brownville. I have an impression that there was a young man with Crouch part of the time, but can't say for sure. After he started with us up the Watertown road, I revived slightly and struggled out from under the women. Crouch then hit me on the head with a stone or something sharp, and whenever I would move or show signs of life, he would pound me on the head and shoot me. After

Postcard of Madison Barracks at Sackets Harbor. *Copyright 1905 by Rotograph Company.*

we had gone some distance, the man pulled me from the buggy and threw me into a creek or pond. I floated ashore and crawled up the bank and across the fields to the hospital.

Allen then implored the coroner and doctor to hasten to the scene of the crime in nearby Hounsfield and search for the women, whom he said were probably still in the creek. News of the slain women had not yet reached the barracks, so Allen was told that the women were probably fine, or they would have heard about it. He knew better, of course, even if those assisting him to the hospital were unaware of the murders. Soon, every detail of Allen's initial story would be questioned and ultimately debunked, like his statement that he only owned a small caliber weapon that he used to kill cats with; yet, he had given a boy named Frank Gomery some money to go to the store just hours before to purchase a new revolver for him. But Allen was cut some slack on account of his own injuries and the possibility that his confusion stemmed not from being caught up in his own lies but because of either shock or head injuries suffered during the ordeal. Furthermore, doctors in charge of his treatment at the army hospital refused to let investigators speak to him, which stifled the investigation considerably. According to Dr. Ware, he had "three wounds on the right side of the neck, with two cuts in the

Wilbur Crouch. Photograph from the *Watertown Herald*, 1897. *Printed with permission from the* Watertown Daily Times.

forehead, as if he had been struck with a stone. There was one bullet wound over the right temple and a contusion on the left breast, while his head was covered in bruises." Crouch, who was forty-four years old, had become the most viable suspect simply because poor Private Allen—the wounded steward of the officers' club—had said so.

Constable Maxon was sent to arrest Crouch and said:

> *I went to the place and knocked at the door. In about two minutes, Crouch unlocked it. I opened it and went in. He was dressed in his stockings and drawers and was pulling on his pants. He said, "What do you want?" I said, "I want you, Crouch. Your wife and Mary Daley [sic] have been murdered, and Allen is only just alive. I must place you under arrest." Crouch started and, striking an attitude of surprise, said, "My God, what will my poor children do?" I said, "Crouch, do you know anything about this?" He said, "Not a thing."*

Crouch had been a butcher by trade and bore a reputation of being an "ugly drunk" with a penchant for gambling. His wife left him on account of his drunken tantrums. But he insisted he held no ill will toward her and knew nothing about the horrible murders. The *Herald* said:

> *His long-standing trouble with his wife, his quick temper, and the statement of Allen, all helped to fasten the crime on him at the start. He tormented his wife, who was separated from him, but not a word against her has passed his lips. He believed her a virtuous woman and has maintained this from the beginning of their troubles, which he claims was due mostly to his own temper.*

For example, according to the *Herald* of April 24, 1897, Mrs. Robert Morris testified at the coroner's inquest that she had stepped in and protected Mary Crouch on more than one occasion:

> *I have known Mary Crouch for more than ten years. There was no bright spot in her life except when with her little ones Sunday afternoons. Mrs. Crouch was a hard-working woman. She had earned her own home by sewing and taking in boarders, when her husband would come home,*

Mary Crouch. Photograph from the *Watertown Herald*, 1897. *Printed with permission from the* Watertown Daily Times.

kick, choke, and pound her. She fled to my house for protection many a time. I have caught him choking her, and I have saved her life. I was not afraid of him.

Yet, regardless of the allegations of spousal abuse that resulted in Mary Crouch securing a "limited divorce" the previous fall, some, even at that earliest juncture, believed Crouch to be innocent, including Chief of Police George Mason. And many were beginning to wonder if Allen knew more than he was willing to admit. The *Herald* said:

Some believe that he [Allen] became too familiar with the women in the buggy and that Mrs. Crouch drew her revolver to defend her honor; that Allen may have drawn his to frighten the women, and the shooting began; that after he saw what he had done, he walked to the barracks and let the team go with the dead to the stable. There is but very little time between the arrival of the team at the barn and Allen at the barracks. His purchase of a revolver the day before, his talk of Crouch watching him,

his approaching marriage under peculiar circumstances, even the little slips in his delirium talk, are worked together to form a chain of evidence to convict him instead of Crouch, but the officials seemingly are ferreting out evidence to convict Crouch.

Hence, Crouch's sleeping quarters, dubbed "the shack," were searched, with the only suspicious findings being a couple of handkerchiefs stained with blood that was later determined to be animal and nasal (nosebleed) blood and a book about crimes and criminal escapes. The *Re-Union* said, "The book was found open at the exciting story of the escape of a man accused of murder." But his horse and buggy showed no signs of having been out that evening. It had been a wet, messy night, but there were no signs of mud on the horse or buggy, whatsoever; and his overcoat was likewise clean. Had he been involved in such a horrific scuffle as this, it wouldn't have been so. Crouch told a reporter:

I was coming up at about 7:45 with a man named Simmons and another man on the road leading from in back of the barracks onto the main road. They walked with me as far as Longworthy's. Afterwards, I went to the hotel and stayed around till a little after 9. I didn't go home till 10. A man named Sprang walked part way with me. I went home and went to bed.

This alibi was corroborated by a number of individuals, including "Joe" Roach, who knocked on Crouch's door at the time the murders were believed to have been taking place to see if Crouch felt like a game of poker. Crouch clearly replied, Roach said, that he did not before going back to sleep.

At the coroner's arraignment of Crouch, Judge W.F. Porter came to his defense, saying, "We are at the mercy of a man who *did* commit this crime, in my judgment, and would perjure himself and send himself to perdition for the purpose of saving his own life and freeing himself from the consequences of a deed which he himself committed and would fasten upon an innocent man." Still, the coroner's jury "rendered a verdict to the effect that the two women came to their death by bullet wounds believed to have been administered by Wilbur Crouch." Crouch was then locked up in the county jail, as confident as you would expect an innocent man to be that his counsel would soon get to the bottom of it and have him released.

Crouch's attorney, Nathaniel F. Breen, meanwhile, continued to sort the fact from the fiction of Private Allen's account and began to rapidly accumulate a preponderance of evidence against the hospitalized so-called third victim of this tragedy. First of all, George F. Allen was really Edward George Haynes; and even though he was engaged to be married to Mary Daly that very weekend, he was *still* married to Nellie Barnacle of Chicago, whom he had wed only a half year earlier. *And* he was engaged to yet another young lady named Fanny Waters, besides Miss Daly. What's a poor man to do?

Shortly before the murders, Haynes made the mistake of confiding in a number of acquaintances that he was in a predicament. A saloon proprietor, for example, testified that on the day of the murders, Haynes came into the saloon and confessed to him, "I am in trouble, and I don't see how I can ever get out of it. I might as well shoot myself and end it all!" To Albert Parker, who was delivering milk to the officer's club shortly before the murders, Haynes allegedly said: "Parker, I'm in a h———l [*sic*] of a fix. Mary Daly wants me to marry her, and I won't do it." Then, according to Parker, Haynes "threw up his hands and pulled imaginary weapons from his coat, saying: I've a good notion to blow my brains out!" He must have decided the only way to prevent the unlawful marriage to Mary Daly from taking place that weekend was to simply do away with either himself or her and lay the blame upon another man. So he hatched a carefully considered plan that conveniently involved Wilbur Crouch as the scapegoat killer, making sure to drop hints to various persons he encountered that evening, including Mary Crouch, that he believed Wilbur Crouch was following them, knowing all along it was untrue.

It didn't take Breen long to size up Haynes. But others remained under his spell, including one reporter who called him mild mannered and courteous. The reporter described Haynes as having light hair and a light mustache, a tall athletic build and expressive grayish-blue eyes and said, "He was considered one of the best athletes among the troops at Madison barracks." Breen was not impressed. It didn't take him long to see that his client, Wilbur Crouch, was being unlawfully detained. So the attorney summoned Special County judge A.E. Cooley to Watertown. Upon the judge's arrival, Breen made an application for a writ of habeas corpus, which was duly granted. According to the *Re-Union*, the writ was served upon Sheriff Kellogg, who was ordered to appear before Judge Cooley two days later:

The writ was granted to compel the people to show cause why Crouch is retained in jail. He was arrested a few hours after the murder was committed, detained at the Earl house at Sackets Harbor until the verdict of the coroner's jury was rendered and then was brought to Watertown by Constable Maxon, of Sackets Harbor, and lodged in jail here. No warrant was issued for his arrest, and he has had no preliminary examination before any magistrate.

The law provides that a person must be given a hearing within 48 hours and that he cannot be detained without legal process.

Crouch was thereby formally and properly arrested (rather than being released), but he had faith he would be exonerated. He told a *Re-Union* reporter,

I hope to be out of here soon. I don't think they are going to try to indict me, though if by any possibility they should, this would be a pretty tough place to spend the summer. This is a civilized age, and there is no danger of an innocent man being convicted. I have perfect faith in the district attorney. I think he is trying to find out the truth, and if my staying here a few days more will help him, I'm perfectly willing to do it.

Does that sound like a man hiding something?

On April 28, 1897, Wilbur Crouch was brought before Recorder Cobb for an examination on the charges being made against him; but because there were no witnesses to testify against him, the examination was adjourned. Then, on May 17, 1897, the grand jury returned a true bill against George Allen. He was arrested and brought to the county jail, and Crouch was finally released from Cell No. 1 of the east wing of the county jail where he had been incarcerated for a full month. Haynes—who had just been released from the government hospital at Madison Barracks—immediately took up residence in the very same cell. I wonder if they passed each other in the hall, as one was leaving and the other was just arriving. It was Haynes's turn now, even though he was not fully healed of his wounds. He had been shot in the head from behind, either by himself or at the hands of another, and the bullet had lodged over his right eye. Another bullet had entered Haynes's neck on the right side and lodged against his lower jaw bone; and two additional bullets

were still believed to be somewhere in his neck, not causing him any trouble, at the time of his arrival at jail. Two stray, innocuous bullets were the least of Haynes's worries, though. He had to suspect, by then, that he would never walk free again.

On May 19, 1897, Haynes pleaded not guilty at his arraignment but was indicted for the first-degree murders of Mary Daly and Mary Crouch. The trial for the murder of Mary Daly, one of the most sensational in Jefferson County history, would be first; it was set for August 31, 1897. Because of the widespread publicity of the case, an additional panel of two hundred jurors was drawn. Justice Maurice L. Wright presided. District Attorney Virgil K. Kellogg was assisted by county judge E.C. Emerson and Joseph Nellis; Haynes was represented by Frank H. Peck and Watson M. Rogers. Judge Emerson opened for the prosecution, describing in great detail, according to the *Watertown Re-Union* of September 15, 1897, how the defendant planned to leave both women for dead and frame Wilbur Crouch:

Judge Edgar C. Emerson. *From Emerson's* Our County and Its People *(1898)*.

And here we see him [Haynes], engaged to marry two women and legally married to a third. Now gentlemen, it was discussed between this defendant and Mary Daly that they were to go to Oswego and that she was to apply for her divorce there, and that they were after to marry. They were to have left for Oswego on the next day after the murder, and after the divorce had been obtained they were to have been made man and wife. She had packed her trunk and made all due preparations to leave the garrison. The defendant had also informed the officers of the Officers' club, where he was employed, that he was to leave the service on that Saturday. A new man had been provided to take his place. Mary Daly and Mary Crouch had been bosom friends and on many occasions, he had been seen with them. After it had been arranged to go to Oswego, a trip was laid out when Allen was to take the two women and drive them to Mrs. Carr's for a farewell visit.

On the morning of the 15th, a man named Rhinehardt was engaged to take charge of the club house in the place of Allen, who was expected to leave. He came to Allen and asked him what to do, as he was, of course, unacquainted with the duties of the position. Allen told him when he appeared that he had decided to remain the month out, and also said the job was a hard one anyway, and no kind of a job. He told the new man to tell Lieutenant Connell, who had sent him, that he could not take charge of it at present, as he had to work around his place, and the man did as requested…That morning, also, Allen secured the services of a young boy named Gromeley, who ran errands for inmates of the garrison, and sent him to the village to buy a self-acting 32-caliber revolver and a box of cartridges for it. The defendant had another revolver which he is understood to have used to shoot cats. The boy fulfilled the errand as requested, and when he came back and handed the revolver to the soldier…and when Allen had got it, he put it in the cupboard with the remark that he had to send it away. This is a revolver that he afterward said in one of his statements that he had sent to Billy Moore. Gentlemen, I think we will prove to you that this was a falsehood, and that Allen never sent that revolver away; that it was not on the shelf the next morning in the cupboard where it had been left; that it did not pass out of Allen's possession, and that it was the revolver with which the shooting was done.

The Mary Crouch–Mary Daly Double Homicide

Emerson went on for the remainder of the morning to carefully describe, in meticulous detail, the activities and actions of the defendant and his victims on the night of the murder, from the time Haynes picked up the horses and buggy at the livery stable until he came staggering into the mess hall. Following the lunch break, Emerson continued, describing the sounds witnesses had heard along the alleged route of the crime, corroborating the prosecution's version of events. He then went into detail regarding the condition of the victims and the defendant and what their expert witnesses had to say about it:

> *The clothes worn by the two victims, Allen and Crouch, have been submitted to experts, along with other things. A second autopsy was made with the aid of the microscope. On the front and side of Mary Daly's clothing, the fire had burned it away. The two bullet wounds had passed through her cloak and the holes had been burned out, the result of contact shots and some grains of powder were in her flesh. There is a certain quantity of powder that is not burned and it tends to spread itself out. With experiments made*

Original photograph of carriage carrying the bodies of Crouch and Daly. *From the collection Robert and Jeannie Brennan, Sackets Harbor.*

by the same revolver and similar cartridges, it was held within three inches of Mary Daly's neck when the discharge took place.

 It was found that Mary Daly's cloak was smeared with mud…There were burns on Mary Daly's legs below the stockings, but there were no burns on the stockings. There was mud on the outside and inside of her stockings…which would indicate that her stockings were pulled down over her shoes and afterward pulled up. The mud on Allen's shoes was the same as on Mary Daly's shoes. An examination showed that the shoes worn by Allen and Mary Daly fitted the tracks on the Burton place…It was found that the bullet in Mary Daly's breast was a 22-caliber bullet, and the bullet that went through Allen's coat was of the same size. All other bullets were of 32 caliber. It was further found that all the bullets were from Allen's revolver.

After reminding the jury that Haynes had motive—he was engaged to Daly and Fanny Waters, married to Nellie Barnacle all at the same time and knew he was in trouble if he didn't do something about it—Emerson said Haynes came up with a diabolical plan. He would secure a revolver, take a road trip, as it were, in the guise of a farewell visit to Mrs. Carr's and convince everyone that he was being stalked by Crouch, whom Haynes knew would make a worthy scapegoat. Crouch's anger issues were well known within the community. Emerson closed his opening statement by saying:

The people believe that the key to the transaction is that Allen pulled the 22-caliber revolver and hit Mrs. Crouch in the breast. Then the struggle began, and the bullet went through Allen's coat. After trying to fire that revolver without success, the 32-revolver was pulled and Mrs. Crouch was killed. It was getting too near the village, and they drive to the Burton place. Mary Daly escapes from the buggy, but the assassin pursues her and ends her life. He puts her back in the buggy and starts back. Dazed and not knowing what to do, he starts to burn the bodies. The fire is extinguished and then the drive was made over the ford and back to the Watertown road, where it was turned around and came back to the stable. We don't know where the bullets in Allen's neck came from. They may have been self-inflicted or received in the fighting. We believe you will see all these facts clear and find the defendant guilty.

Attorney Frank H. Peck. Sketch from the *Watertown Herald*, 1897. *Printed with permission from the* Watertown Daily Times.

Even after the defense's impressive effort to cross-examine Crouch, the original suspect, and convince the jury that he was still the more likely perpetrator of the gruesome double-homicide, the evidence against Haynes was overwhelming. But that didn't stop Frank Peck and Watson Rogers from doing their duty on behalf of Haynes. The *Herald* said that Rogers spent a full day making his plea for the prisoner.

> *He opened in a low, earnest tone, with a graceful compliment to the judge and jury and as he proceeded, his powerful voice brought out the words calculated to free the prisoner. There was logical reasoning as he explained the evidence, biting sarcasm in referring to numerous actions of the defense, and severe satire where occasion seemed to demand it.*

The court room was filled. As he began, one watching the jury could not help noticing a coldness, an air that said they knew all about it, but as he proceeded, this was changed, and when he came to the analysis of the evidence, they showed an anxious interest in his remarks. And this interest he retained until the close of his argument. The plea will go down in history as a model address to a jury.

District Attorney Kellogg followed the next morning, Friday, October 29. His closing address to the jury, showed "step by step how the murderer had been tracked, [and] how link by link the chain had been made, until there was no doubt in his mind who was guilty of the death of Mary Daly and Mary Crouch." The *Herald* said, "Mr. Kellogg surpassed any of his previous efforts." And the *Re-Union* said it "was one of the most notable addresses ever made by a prosecuting officer of this county." Kellogg had to prove not only that Haynes was to blame but also that Crouch was an innocent man who had been framed. Hence, the district attorney had a double task to accomplish. But he did it admirably, and it paid off.

The following evening at six-fifteen, Deputy Sheriff Thomas Ballard notified Judge Maurice G. Wright that a verdict had been reached. Because nobody was expecting an early decision (since both sides had been so compelling), there were only a dozen people in the courtroom, if that. Most had gone home for dinner, figuring it would still be a while. Nobody thought it would take the jury only five hours to come to a decision on a trial that had lasted a grueling eight weeks. Once the attorneys for both sides had arrived, the judge took his seat at the bench, the jurors filed into the room and county clerk Frank D. Pierce said, "Gentlemen of the jury, have you agreed on your verdict; who shall say for you?" Jury foreman H.E. Carpenter stood and said, "We find the prisoner at the bar guilty of murder in the second degree." Haynes showed no sign of emotion. Attorney Peck moved for a new trial—which the judge denied—and then he moved for a new trial again on the grounds that decisions of the court had been erroneous and evidence offered by the prosecution had been at fault. Again, the motion was denied. On the morning of the sentencing, two days later, according to the *Herald*, Haynes was told, "The sentence and judgment of the court is that you be confined in the state prison in the city of Auburn for and during the term of your natural life."

The Mary Crouch–Mary Daly Double Homicide

Early postcard of a cell block at the state prison in Auburn. *Courtesy of the author.*

Two years later, a blurb in the *Watertown Herald* said, "George Allen, the murderer of Mary Crouch and Mary Daly, is still doing hospital work in Auburn Prison. He is considered the best nurse there and appears cheerful and always ready to do his keeper's bidding." In 1907, a new law regarding parole for prisoners who had been sentenced to life was created. It stipulated that

> *murder in the second degree is punishable by imprisonment under an indeterminate sentence, the minimum for which shall be twenty years, and the maximum the term of the offender's natural life; and any person serving a term of imprisonment for life murder and originally sentenced for murder in the second degree, when this act as amended takes effect, shall be deemed to be thereafter serving under such an indeterminate sentence.*

In other words, this law would allow Haynes to be eligible for parole after serving twenty years. Fast forward to 1916 when the state prison commission, touting Haynes's "perfect record" at Clinton prison in Dannemora, announced that he would go before the parole board in 1917. He had been transferred to Dannemora "in order that he might spend more

time in the open air" because he was "broken down in health," according to the *Journal and Republican*. When he returned to the state prison at Auburn, he appeared "greatly improved in health" and weighed nearly two hundred pounds. District Attorney Virgil Kellogg adamantly opposed the parole of the prisoner and wrote the parole board, "saying that he [was] unalterably opposed to the granting of the parole." He said he considered Haynes a dangerous person to be at large. I could find no further mention of Haynes in the sources at my disposal, so it is likely that parole was denied. Had he been released, it would certainly have made news locally.

As for Wilbur Crouch, he drowned in December 1902, just five years after the Crouch-Daly nightmare. At the time of his passing, he was the second mate of the steamer *Sylvester J. Macy* of Detroit, which foundered and sank, taking all hands on board to the depths of Lake Erie.

THE SUSPICIOUS PASSING OF MARY OCKWOOD

HENDERSON, 1897

Less than three weeks after the murders of Mary Crouch and Mary Daly, while most of the county's legal resources were already stretched thin working on that case, another Jefferson County woman named Mary met a tragic, mysterious end just ten miles south of the Crouch-Daly murders. On Saturday morning, May 8, 1897, the body of a "half-breed" French Indian woman was found on the shore of Warner's Island, about two miles from Henderson, by L.J. Vorse, who occupied a farm on the island. A single oar and two baskets had washed ashore alongside the body. Coroner W.H.H. Sias of Ellis was notified and arrived the next day. Upon viewing the body, he ordered it taken to Henderson where a postmortem could be performed by Dr. Olin F. Buell. The autopsy, according to the *Watertown Herald*, "indicated that the woman had not drowned, but had been killed by heavy blows on the head, producing sufficient injury to the brain to cause death, though the skull, which was of abnormal thickness, was not fractured." Early news articles stated that there was a wound over the right eye consistent with a blow made by a sharp object, such as a boat hook; and a large contusion on top of the woman's skull appeared to have been made by a heavy club. "The woman," according to the *Herald*, "was last seen alive in Sackets Harbor the previous Thursday, when she was in company with a medium sized half-breed, supposed to be her husband."

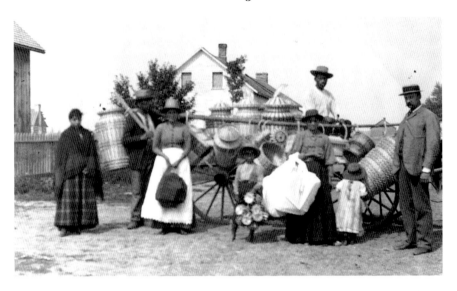

Photograph by W.S. Tanner, 1894. *From the Library of Congress Prints and Photographs Division.*

The deceased was soon identified as forty-year-old Mary Arquette. Investigators learned that she and her husband, named "Rasfan Arquette" in several papers and "Aaron Alquit" in others, had lived with a St. Regis Indian basket maker named "Big Louie" Antro for nearly two years in a small house at 8 Haney Street in Watertown. The couple had no children living with them at the time, and they had a very quiet existence—so quiet, in fact, that none of the neighbors even knew their names; they knew of them only by appearance. When questioned during the coroner's inquest, Louie said the couple always seemed to get along fine, with little quarrelling or fighting. They did, however, like to drink heavily on occasion. Louie recounted how the couple had decided to return to the St. Regis Mohawk Indian Reservation up in Franklin County, where they were both from, and they had agreed that the most economical way to do this would be to purchase a skiff and row up Lake Ontario, the St. Lawrence River and, finally, the St. Regis River. So they purchased a boat from a Mr. Wagoner at Henderson Harbor ten days before their trip and stored it at E.A. Hovey's boathouse in Sackets Harbor until they were ready to use it. On Thursday, May 6, 1897, Nelson Montondo kindly drove them from Watertown to Sackets Harbor where they set sail, their first destination being Bull Rock, at the extremity of Pillar Point. The wind was blowing something fierce that

day, and the couple had been drinking rather heavily—not a good recipe for a safe journey on choppy water.

The *Herald* of May 15, 1897, said:

> *They were thus in the trough of a heavy sea stirred up by the northeast wind, which was blowing half a gale when they left the slip at Mr. Hovey's boathouse and went out around Ship House Point.*
>
> *The wound on the woman's head was caused by a blow. One thing is a practical certainty; the woman was killed either on shore or in a boat and her body thrown into the water. This is circumstantially proven by every post mortem finding.*

Mrs. Arquette had money on her when they left, but none was found on her when her body was discovered. Louie said that Mary was the "purser of the household," meaning she held and dispensed of the money—at least what little the couple had. He said he was absolutely certain that any money they had would be found on the woman and not on her husband. Yet, nothing of value, except a string of beads, was found on Mary Arquette. Thus, in the absence of Mary's husband to defend himself, he was beginning to appear guilty, the theory being that he killed his wife and fled.

District Attorney Kellogg, Sheriff Kellogg, Charles Forsythe and Dr. J.D. Spencer all went to Henderson on Sunday night. The district attorney asked Deputy Sheriff Harrison Algate and Constable George Allen to thoroughly search the shoreline where the body was found. This they did at daylight on Monday, searching the water and the shore for any sign of the missing man to whom Mary Arquette was married. Their search proved futile. However, the next day, the plot thickened.

The *Herald* reported:

> *Tuesday morning, the boat with which Arquette, the alleged husband of the murdered Indian woman, left Sackets Harbor was found at White Bay [sic] in Henderson Harbor. The missing oar, baskets and mattresses were found near the boat, and other things that they were known to have with them. With the wind that has been blowing, it seems impossible that the boat could have drifted to the place found, and it is believed that Arquette abandoned the boat at that point and escaped.*

Choppy waters on the St. Lawrence River. Photograph by Detroit Publishing Company, 1890. *From the Library of Congress Prints and Photographs Division.*

And the *Re-Union*, which had determined that the correct surname of the couple was Ockwood and not Arquette, chimed in, rather harshly, saying:

On Tuesday morning the boat in which the Indian and his wife left Sackets Harbor on the afternoon of May 6 was discovered bottom upward on the shore of White's bay opposite Henderson Harbor. Experienced watermen say it could not have drifted to that point, where the woman's body was found. A short distance from the boat was found a mattress, rolled up and tied, as it had been when the Indians left Sackets Harbor. The end of the rope which bound the mattress was bound securely around a bush on shore in such a manner that it was at first thought it had been done by the action of the waves. In view of later developments, it is thought that the fastening of the rope was the work of the Indian.

A man with enough shrewdness to try to cover up a crime by manufacturing evidence that he was drowned would know better than to purchase a ticket at a small way station near the scene of the crime. He would naturally ride a freight or board a passenger train and pay his fare on the train. Conductor John Lennox, who runs a passenger train between Oswego and Suspension Bridge, has informed W.J. Dempsey, of Oswego, the R.W.&O. Detective, that on Tuesday afternoon, an Indian who closely corresponded with the

description of Ockwood boarded his train at Ontario and rode as far as Windsor Beach, at the mouth of the Genesee river and opposite Charlotte. The Indian had no ticket, and when he paid his fare on the train, he displayed a considerable sum of money. He had been at Ontario nearly all day Tuesday and had been eyed with suspicion by the villagers.

Meanwhile, Dr. Spencer made another examination of the body, as did Dr. A.E. Goss of Adams, who was called in by Coroner Sias for a second (or third) pair of eyes. Third time's a charm. It was on this third examination of the body that a fracture of the skull at the base of the woman's brain was first noticed. Remember that the initial autopsy showed an unusual thickness to the skull, but no fracture? With the latest revelation, Coroner Sias concluded the coroner's inquest, and a verdict was soon reached.

The *Re-Union* of May 19, 1897, said:

[On May 12] *After a discussion of the case by the coroner and the jurymen, the jury [was] left to consider the verdict. At 3:15 the jury rendered the following verdict:*

"We the undersigned jurors, find that the deceased came to her death by blows received on the head and the body, inflicted by her husband with a club or heavy weapon at or near Six Town Point, on or about the 7th day of March, 1897."

All the jurors except Reuben Bunnell signed the verdict. Bunnell dissented from that portion of the verdict which described the weapon with which the injuries were inflicted and identifying Ockwood as the murderer.

Smart man, Bunnell. But we'll get to that later. With a supposed killer on the run either westward, as conductor Lennox suggested, or north toward the St. Regis Mohawk Reservation, Coroner Sias telegraphed Sidney Grow, the former Indian commissioner at Hogansburg, New York, where the reservation is located, and told him to be on the lookout for Ockwood. Shortly after, Aleck Pork, Mary's brother, arrived from the reservation to identify his sister's body. He brought a marriage certificate to prove that the Arquettes were really the Ockwoods. His sister, he explained, had married William Ockwood (aka James Ockwood, Aaron Alquit and Rasfan Arquette) in 1892, but he wasn't sure where the wedding took place. It was her second marriage,

and she had a son named Andrew Phillips from her first marriage who lived with her mother on the reservation. She was surely looking forward to seeing him again. William had a daughter "living somewhere at school" and a son that had drowned at Kingston three years earlier. Both of his parents were deceased, but a brother still lived on the reservation. While Pork shed much light on the couple's married life, authorities only had his word and that of Louie. No other witnesses were ever questioned in the matter.

According to the *Re-Union* of May 19, 1897:

> *Pork stated that since the marriage of William Ockwood and his sister, they had lived in Kingston, Watertown, and Brownville. About a year ago, in May 1896, [Pork] left Kingston and went to St. Regis. The following day, he was joined by his mother, who was bruised and wounded in both eyes and over the head. She told him at that time that William Ockwood had assaulted her, beating and kicking her, and [Pork] knew that she was sick a long time from the effect of her injuries and came near dying. She also said at that time that Ockwood had pounded his wife, and that she got away.*
>
> *Pork said when Ockwood had two or three drinks, he was crazy and manifested murderous tendencies. His desire, however, was always to kill or injure some woman, and he would not trust the man.*
>
> *William Ockwood, he said, was an expert with a boat, used to the water, was formerly a log driver, and an excellent swimmer. The witness did not know what Ockwood could do in water when he had been drinking. He said that Ockwood did not seem like the same man when drunk.*

Pork's statements seemed to validate the jury's finding that Mary had been beaten to death at the hands of her husband. Everyone was so sure of it, in fact, that the *Re-Union* said, "There is little doubt, in the light of known facts, that James Ockwood, Rasfan Arquette, or Aaron Alquit, as the Indian wife murderer has been variously known within the past two years, is alive and seeking to conceal himself from those who would hunt him down and punish him for his crime." The paper reminded its readers that the district attorney and the sheriff knew within thirty-six hours of finding the body that a murder had been committed, saying, "During this period of time, Ockwood was unsuspected, save by a few, and could have made his way on foot half way across the country without being molested." But can a dead man do that?

The Suspicious Passing of Mary Ockwood

Three weeks later, on May 31, 1897, Ockwood's body was found, and the matter was quickly put to rest, probably because authorities still had the Crouch-Daly murders to sort through. The *Herald* reported:

> *The body of a squaw was found on Warner's island in Lake Ontario near Henderson harbor, May 9th. Death, it was announced, had resulted from injuries to the head, and the case was said to be one of murder. An Indian, Aaron Arquette [sic], was accused, but he could not be found. Sunday, the Indian's body was washed ashore at Sackets Harbor. This clears up the mystery, as it is now believed that while drunk, they both fell out of the boat and were drowned.*

Did it *really* clear up the mystery? Because the coroners, physicians and authorities sure had seemed pretty certain that Mary Ockwood was murdered before her husband's body was found. They had previously announced, prematurely in retrospect, that "the woman had not drowned, but had been killed by heavy blows on the head." The jury said, "We the undersigned jurors, find that the deceased came to her death by blows received on the head and the body, inflicted by her husband with a club or heavy weapon at or near Six Town Point." And what about this announcement? "One thing is a practical certainty; the woman was killed either on shore or in a boat and her body thrown into the water. This is circumstantially proven by every post mortem finding." Circumstantially proven? A practical certainty? How could the discovery of Mr. Ockwood's body have instantly exonerated him from a crime that so many had been so certain that he committed, simply because he appeared to have drowned? Bunnell, the lone juror who refused to sign the verdict, was right to not jump to conclusions. That's not to say that it's inconceivable that, in a drunken rage, Ockwood bludgeoned his wife to death and tossed her overboard, then accidently went over himself—having lost his footing on the choppy waters in his highly intoxicated state, or that perhaps the couple's serious head injuries were caused in a fall in the boat before or as they were being cast out into the rough waters. There are countless scenarios, and we will never know, at this point, what happened. For all we know, both husband and wife were slain and robbed by someone who had seen them with money in Sackets Harbor. In the end, their deaths went down in the books as accidental drowning—and authorities were reminded that things may not always be as they first seem.

THE GRUESOME "WATERTOWN TRUNK MURDER"

HOUNSFIELD, 1908

Jammed within the narrow confines of a trunk, with her head mashed to jelly, one ear gone and her body mutilated until recognition was almost impossible, the body of Mrs. Sarah Brennan, wife of Patrick Brennan, of Brownville, was found Monday afternoon in a back kitchen at the home of Mr. and Mrs. James Farmer of that village.
—Watertown Re-Union, *April 29, 1908*

In October 1907, Mary Farmer hatched an elaborate plan to criminally acquire the property of her neighbors so that her young babe, Peter, would one day have something of value that she believed she and her husband, James Farmer, could never provide otherwise. (Heaven forbid that they should have to work for their material possessions like the rest of us.) The fact that a cold-blooded murder might become necessary for her to meet this sinister objective was but a trivial detail that the soon-to-be murderess would worry about when the time came. That time came on the morning of April 23, 1908, when Sarah Brennan paid a routine visit to Mary Farmer. Neighbors later claimed to have heard the women arguing. One can only surmise that Sarah had finally learned of Mary's plot to steal her house and home right out from under her. She would have to be silenced.

Some said that twenty-four-year-old Mary "had never fully recovered her mentality" after the birth of her only child in 1907, but countless others testified that her peculiar behavior spanned years, culminating in the one

The Gruesome "Watertown Trunk Murder"

Portrait of Mary Farmer, 1908. *Printed with permission from the* Watertown Daily Times.

unspeakable act—when she raised the hatchet over the skull of Sarah Brennan—that sealed her fate. Although there was never any doubt about Mary Farmer's *guilt*, her mental state at the time of the gruesome murder would ultimately determine whether the young mother should live or become the second woman sent to the electric chair in New York state. Hence, much time at the inquest and later trials would be devoted to determining if Mary Farmer was sane when she slaughtered her so-called friend and neighbor. Even more time would be spent determining what role, if any, her husband had played in the whole affair.

It all began when Mary Farmer forged a deed to the Brennan residence that was recorded in the county clerk's office. Somehow, she managed to steal the deed from the Brennan house on one of her many visits to call on Sarah Brennan. The property, located on Paddy Hill in Hounsfield, across the river from Brownville, was adjacent to the Farmer property (known as the old Barton Hotel), and the women visited often. Although the Brennans were not wealthy, by any standards, they enjoyed life's simple pleasures and

seemed content. For Mary Farmer, living eighty feet away must have become increasingly difficult to tolerate because she was reminded daily of what others had that she wanted. The Farmers had lost the previous home they owned near Ontario Mill when they were unable to make payments, and Mr. Farmer had not held a job for some time. They had almost nothing of value. Thus, with an inexplicable sense of entitlement, Mary Farmer made a conscious decision to turn her growing irritation into an opportunity for herself and her family. On October 31, 1907, she went before Attorney Francis Burns at the Jefferson County clerk's office impersonating Sarah Brennan. There, she transferred the deed to the Brennan home to the Farmers for the sum of $2,100 (roughly $50,000 in today's dollars) and forged fifty-five-year-old Sarah Brennan's signature.

Once that first crucial step was accomplished, Mary Farmer began slowly spreading the word around town that she had purchased the property from the Brennans so that it wouldn't come as such a surprise when Sarah Brennan disappeared and the Farmers moved into their home. And, while the Brennans heard occasional rumors that they had sold their property, they adamantly denied them and wondered how they had started. On January 7, 1908, the Farmers boldly deeded the property they had illegally acquired to their son, who was then ten months old; and they transferred the insurance on the house from the Brennans to themselves. Phase one of the plan was complete. All that was left was to remove the oblivious couple from the premises. For reasons unknown, Sarah Farmer waited four months to complete her plan. Some speculated that the delay was due to "timidity to commit the deed and the presence of relatives."

Thursday, April 23, started out like a normal day for the Brennans, other than the fact that Sarah had, ironically, dressed in black in memory of a daughter who had died some time before on that date. But she was fine when she paid a visit to the Brennans' home that morning to see if her "friend," Mary, wanted to ride with her to a dentist appointment in Watertown. Something must have snapped at that moment in Mary Farmer's criminal mind, for she decided then and there that it was the day she had long waited for. Opportunity knocked, literally, the moment Sarah Brennan reached her doorstep.

Pat Brennan went to work at Globe Mills that day, where he ran a boiler. He and his wife could never have imagined the events that were about to

Courtesy of the author.

transpire when they set out in their respective ways that day. According to the *Watertown Re-Union* of April 29, 1908, Mr. Brennan came home to find the door locked and the key missing from its secret hiding spot:

All was happy when Mrs. Brennan left him for his work at the C.R. Remington mill that morning. When he returned that afternoon, he found the front door locked. He felt behind the blind for the key; and, not finding it, went to the barn, which was also locked. With a hammer, he pulled the hasp, secured a ladder and entered a window. He thought that perhaps his wife was out calling, but wondered that she failed to leave the key.

Ten minutes later, Brennan was at work tearing down the stormhouse. He had almost finished when Farmer, who had not been working for some time past, came to the fence.

"Don't you know that I own that place now," said Farmer. Brennan turned in amazement and replied that he did not. "Yes, the place is mine, all right," continued Farmer. "I bought it last October, and you can see the deed at the county clerk's office. I paid $2,100 for it."

"That's funny," commented Brennan. "My wife never said anything about it, and you neither have said anything about it all these months." Farmer replied that he didn't think there was need of it, inasmuch as Mrs. Brennan had been paying him $2 a week rent for it, but that now he had decided that he would move in and enjoy his own.

Over the next few, surreal days, Brennan could not get a straight answer from the Farmers on the whereabouts of his wife, and he grew increasingly suspicious that they were somehow involved in her serendipitous departure. The day after Sarah Brennan went missing, the Farmers went to Watertown to obtain the following notice from Field & Swan to be served on Mr. Brennan, telling him to vacate his property and informing him that the Farmers had a bill of sale for *all* of the personal property in the house.

To Patrick Brennan:

Dear Sir—Take notice, that by virtue of a deed dated October 31, 1907, and recorded in the Jefferson county clerk's office November 9, 1907, in the book of deeds 325, page 93, your wife, Sarah Brennan, sold and conveyed to me, the undersigned, the house and premises in the town of Hounsfield, Jefferson county, N.Y., near the village of Brownville, in which you and she then resided and have since resided; and that I thereupon became and now am the owner of said property; and that your wife has recently delivered to me the keys and possession of said house and property; that I am now in the sole and exclusive possession thereof and of all the household furniture and personal property in the house, which was sold to me by her by bill of sale and delivered to me, for which personal property I paid her, and I am now in possession thereof, in said house.

That I hereby notify and require you to stay away, remain away, and keep out of this house and off said premises from now on, except to come to said house and get and take away your wearing apparel and personal belongings, which I hereby require that you do before April 27, 1908, and in case of your failure so to remove your wearing apparel and personal belongings, I will leave them with Daniel Woodard at his residence in said town, subject to your order, and I hereby forbid you to come on said premises as and for the purpose stated above.

Dated April 24, 1908

(Signed) JAMES D. FARMER

FIELD & SWAN, Attorneys for J.D. Farmer

The Gruesome "Watertown Trunk Murder"

Not only would Pat Brennan soon learn that his wife had been brutally murdered, but the Farmers booted him out of his own house and robbed him of all of his material belongings. But the property was the least of Brennan's concerns at the moment. All he really wanted to know was what happened to his wife.

The *Re-Union* said:

> *Worried almost to desperation, Brennan came that night to the home of James Rattray in Griffin Street, this city, and anxiously inquired if anything had been seen of his wife. It is alleged that the Farmers had told Brennan many stories of his wife's absence, saying first that she had been selling her property and buying expensive clothing and had left for Duluth. Later, it is alleged, they said that she had gone to Watertown and said she wanted her goods sent to Rattray's.*
>
> *Every story was followed by the anxious husband. No one had seen her leave at the station, no trace of her was obtainable at Rattray's. She had an appointment at Dr. Huntington's for dental work and this she had failed to keep. Brennan investigated and found all her clothing in the closets.*

Two days after being kicked out of his home and told that his wife had left him, Brennan consulted Attorney Floyd Carlisle. The lawyer soon discovered that a woman resembling Mrs. Farmer was the one who had transferred the property at Attorney Burns's office, not Mrs. Brennan. There was definitely something fishy going on. The scheming couple, meanwhile, proceeded to take full possession of the Brennan property, even as an investigation, unbeknownst to them, was about to commence; they were about to be busted. For little did they know—indeed, little could anyone have known or ever envisioned—that a trunk was about to become their undoing in a case that would be forever recalled as the famous "Watertown Trunk Murder." Mary Farmer's black trunk was among the items carried from the Farmer house to the Brennan residence when the Farmers stole the Brennan house. That trunk represented everything: Mrs. Farmer's guilt, Mrs. Brennan's untimely demise, Mr. Farmer's innocence and Mr. Brennan's worst fear.

After learning from Attorney Carlisle that something wasn't right in the handling of the real estate transactions, Pat Brennan alerted District

Attorney Pitcher, and on Monday, four days after the nightmare had begun, Sheriff Bellinger and his assistants were dispatched to the Brennan residence to question Mary Farmer. At first, Mrs. Farmer denied any knowledge of her neighbor's disappearance, but she turned a lovely shade of deathly pale at the start of questioning. Bellinger was onto her. He then proceeded to search the home, determined that he was not leaving without some answers.

According to the *Re-Union*, it wasn't long before he had them.

> *In the back kitchen, the sheriff found the trunk. An odor came from it, and the sheriff suspected that the body was within. When asked for the keys, the Farmers claimed to have lost them, and with a hammer, the lock was forced. A horrible sight met the officer's eyes—a battered countenance, blood and hair intermingling, the body forced and jammed until it filled the space, skirts partly covering the limbs. When the discovery was made, Brennan*

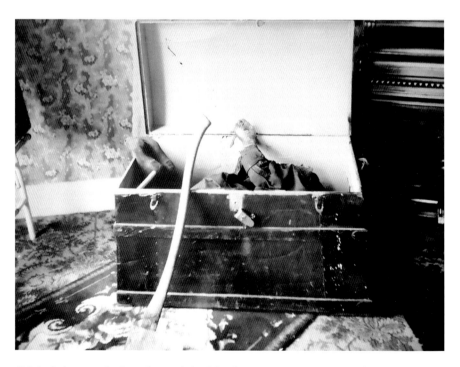

Original photograph of trunk containing Mrs. Brennan's butchered body. On the back of the photograph, "Revelation of a murder" was written *Printed with permission from the* Watertown Daily Times.

and Farmer sat together. "My God, did you do this?" moaned Brennan. "As God is my witness, I did not," replied Farmer.

A moment's consultation and Mrs. Farmer was given a chance to look upon the ghastly spectacle. It was too much, and a moment more a confession was had from her. She said that she had felled the woman with the axe and then washed the instrument and the blood spots from the floor. Later she claimed that, as Mrs. Brennan stepped to the parlor window, Farmer stepped behind her and drove the ax against her head with the exclamation, "There, damn you, I have done with you."

The body was examined by Coroner Charles E. Pierce, along with several physicians, and they found that the left ear had been hacked off, there were three defense wounds on the left wrist, both lips had been cut straight through and a long gash was made on the forehead over both eyes where the axe had broken through the skull. The left jaw was fractured, and it appeared that the victim had been struck from the side first and then "blows had been rained upon the face to finish the job," according to an article called "Cruel Murder" in the *Watertown Re-Union* of April 29, 1908. This finding contradicted Mrs. Farmer's version of having snuck up behind the woman and striking her with the axe. In the trunk with the body, a button from a man's coat, a comb and a torn pocket were found, and the murder weapon was discovered several days later, well hidden from view in a nook in the barn. Beneath a mattress was a blood-stained coat that appeared to have been recently washed, and although the floor had been freshly scrubbed, blotches of blood stains were still apparent. The evidence was clear, abundant and indisputable.

After the initial shock of being found out wore off and a smidgeon of reasoning (disturbed as it was) returned, Mrs. Farmer attempted to lay blame for the murder on her husband. Then she quickly recanted that version and again admitted that it was only she who was responsible. Nevertheless, both husband and wife were taken to the county jail as suspects in the murder of Sarah Brennan. Mr. Farmer, perhaps still absorbing the ramifications of the grim discovery (and the idea that he *lived* with such a cold-blooded killer), wisely said nothing on the way to the county jail. However, Mrs. Farmer, baby at her breast, smiled when asked by the deputy if her dreams had been disturbed, sleeping in the same house as a corpse. She replied smugly that

her dreams were no worse than usual—proof of a mind with no conscience and an impending insanity defense.

A disheveled, weary James Farmer arrived at his arraignment in shackles, led by Undersheriff Charles Hosmer, and Mary Farmer, wearing a blue skirt, heavy plush coat and a shawl over her head, was accompanied into the courtroom by Sheriff Ezra D. Bellinger. The *Re-Union* said, "As far as expression goes, she was as immobile as a statue and looked straight ahead, never shifting her glance. During the time she sat there, not a muscle moved, and she was motionless. Her face was neither flushed nor pale, but it was easily seen that a terrific struggle was going on in her mind." After the charges of murder were read to the couple by city judge Reeves, Brayton A. Field entered a plea of not guilty for Mr. Farmer. Attorney E. Robert Wilcox was assigned to Mrs. Farmer, and the date for examinations of the couple was set for May 6, with Mr. Farmer being questioned first at 9:00 a.m. and Mrs. Farmer at 2:00 p.m. As a result of the incriminating evidence produced at that examination, the couple was brought before the grand jury and indicted on charges of first-degree murder. It was initially thought that perhaps James Farmer was unaware of his wife's plan, especially after she accepted full responsibility, yet there was plenty of evidence that could not be ignored.

According to the *Re-Union*:

> *Damaging evidence implicating James Farmer more strongly as being at least an accessory to the deed developed at Wednesday morning's examination of Farmer before Judge Reeves, when the district attorney produced in court and read the paper signed by Farmer which…became a notice to dispossess Patrick Brennan of the home in which he and his wife had resided for many years, and which even that day sheltered [a] mutilated body…The dispossession notice, signed the day after the murder had been committed, states that Farmer bought the property, had the keys, and warned Brennan to get off and stay away from the home of which forgery had robbed him and which cost the life of his wife.*

Farmer *had* to be aware of his wife's plot. He enforced it by having the notice drawn up and asking Constable Sherman to serve it upon Brennan at once. He, too, had bragged with his wife about having bought the property

long before that fateful day. But had Mary Farmer convinced him that she really did buy the property legitimately with money she had saved from his meager earnings? Had she convinced him that Sarah Brennan was aware of the property transaction and had willingly left town without telling her husband or taking her things? Did she leave out the part where she brutally murdered the poor woman in cold blood? James Farmer seemed genuine enough when he asked Brennan, three days after the murder, if he had heard anything on where his wife went. And when the trunk containing the body was found by the sheriff, it was James Farmer who suggested breaking the lock to open it when the key couldn't be found. Would a guilty man who knew what the trunk held have suggested such a thing without missing a beat? Was he truly unaware that his own wife had murdered Sarah Brennan? Perhaps his only role was enforcing the property transaction to take possession of what he believed was rightfully his. Perhaps he had no knowledge whatsoever of the full scope of the crime. He would have his day in court, but first Mary Farmer, the mastermind of one of Jefferson County's most shocking murders ever, had to be dealt with.

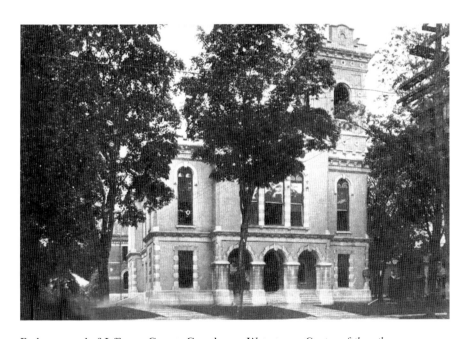

Early postcard of Jefferson County Courthouse, Watertown. *Courtesy of the author.*

Mary Farmer's sister-in-law, Mrs. Michael Doran, had a hunch something wasn't right from the time she arrived at the Farmer residence at the behest of her brother, James, to pick up a deed that he asked her to take to Watertown to have recorded. Mary came to the door and handed her the deed, and Mrs. Doran took one look at it and recognized the signature as that of Mary Farmer, not Sarah Brennan. She asked Mary how much she had paid for the property and was told $1,200. "The woman must have been crazy [to ask for so little]," said Mrs. Doran, according to the *Watertown Re-Union* of May 9, 1908. "Crazy or not, I have the property," was Mary Farmer's response. Mrs. Doran also told the court that Mary Farmer appeared at her home on the day of the murder, around 2:00 p.m., to speak with James, who was helping out there that day. Doran testified that Mary Farmer handed her husband a bunch of keys and said, "There are your keys. Go and see Patsy Brennan and tell him his wife has gone and he has no home." She said her brother exhibited obvious apprehension over his wife's demand, which was very upsetting for Mrs. Doran to see, being his sister.

Many individuals living nearby testified as to the comings and goings of Mary Farmer and Sarah Brennan on the day of the murder. All agreed that they had seen Mrs. Brennan enter the Farmer home around nine that morning but never saw her leave, although, they *did* see Mary Farmer buzzing around all day. Mrs. Charles Baker, for example, swore that she saw Mrs. Farmer "running back and forth from her house to the Brennan's a dozen times," beginning around nine-twenty. Nothing, however, was more incriminating than the testimonies of a young girl named Edith Blake and a man named Philip Smith who had helped carry the storied trunk from one house to the next.

The *Watertown Re-Union* best summed up Edith's testimony in its June 17, 1908 paper:

> *Little 12-year-old Edith Blake told how she had gone to the Farmers' and cared for the baby Thursday. The girl's answers were clear and concise, sticking to the same in spite of any cross-examination. The witness told how Farmer swore and took some keys from his pocket and passed them to his wife, saying he did not want them. Witness said Mrs. Farmer said, "To hell. You won't get a d—— [sic] cent of money." The testimony gave the impression that the Farmers quarreled at the noon hour.*

The girl told how Mrs. Farmer had gone to Doran's and returned, getting some paper from a drawer and again returning to Doran's, where her husband was at work. Once at home again, Mrs. Farmer told the witness to tend the baby while she cleaned the back room, taking some clothes from the bedroom. The witness said that Mrs. Farmer had sent her to a store for some camphorated oil.

It developed during the questioning that Mrs. Farmer was very careful to shut the door to the room which she was cleaning, so that witness was unable to see what was going on. The cross-examination tended to show that about the noon hour, Mr. and Mrs. Farmer had many talks, occasionally going into one of the rooms and closing the door, leaving the child minding the baby.

Philip Smith's testimony regarding the black trunk sealed the deal. The *Re-Union* reported that Smith, who lived one house to the east of the Brennan

Jury for what was dubbed the "Watertown Trunk Murder." *Printed with permission from the* Watertown Daily Times.

house, agreed to help the Farmers move their belongings into the Brennan house on the morning of April 25.

> *Witness told of getting a clothesline to tie the trunk, at the request of Mrs. Farmer, and with her assistance of tying the trunk around twice with the rope, and…tying the trunk around the third time. Witness also testified to getting a gallon jug replenished with ale three times while the moving was going on, the defendant furnishing the money for the beverage. All partook of the ale, but witness could not say that defendant drank any.* [Author's note: The old get-'em-drunk-until-they're-oblivious-trick.] *The defendant told the witness that she would ask Mr. Tierney to help him carry the trunk, because her husband and Mr. Callahan were drunk, and there was something in the trunk she wanted to be very careful with.*
>
> *The trunk was heavy enough to require two men to carry it, and while it was being moved from one house to the other, the defendant followed close after it. No discoloration was noticed under the trunk, and a smaller one was placed on its top…It also developed that Mrs. Farmer was in the Barton house* [the Farmer's rented property] *most of the time before the trunk was moved, but after it was moved, she spent most of her time in the Brennan house.*

Mary Farmer didn't take her eyes off the trunk and made sure that it was never unduly disturbed, for fear of someone opening it. William Tierney corroborated Smith's testimony "of how the trunk was carried and followed in close succession by Mrs. Farmer." Tierney said Mary Farmer told him there was something breakable in the trunk and to be ever so careful while carrying it. The testimony affected the jury greatly, as did seeing a photograph of Sarah Brennan's postmortem head that was brought in as evidence. There was no doubt in anyone's mind that the signatures of Sarah Brennan had been forged on the deed and bill of sale, for the real Sarah Brennan was not the woman who had gone before the attorney and notary public the year before, and there was now no doubt that Mary Farmer was well aware of the contents of the black trunk, contents that Mr. Farmer seemed unaware of when he suggested that the authorities break the trunk open. Mary Farmer was thus found guilty of murdering Sarah Brennan and sentenced to die at Auburn the first week of August.

The Gruesome "Watertown Trunk Murder"

Postcard of Auburn Women's Prison, circa 1922. *Courtesy of the author.*

With that, Patrick Brennan commenced legal action to have the forged deeds declared null and void, so he could regain possession of his property. The Farmers' infant son was put in the care of John Conboy, a member of the Farmer family, and ultimately, he was sent to the Ogdensburg orphanage in St. Lawrence County. The trial of James Farmer, who had been in the Jefferson County lockup since April, was the next item on the agenda. A half year of sobriety had done much to improve his appearance. The *Watertown Herald* said, "In court, dressed neatly and soberly, clean and sober, and much lighter in weight after six months imprisonment," he looked nothing like the man dressed in working clothes the day of his arrest. But as "clean" as he now appeared, there was nothing clean about the crime for which he was being tried. District Attorney Pitcher said, "Never in the history of Jefferson County has there been a crime which could measure to this in cold deliberation and in a cruel and relentless pursuit of a criminal purpose." Still, the defense insisted that their client knew nothing of the murder until the trunk was opened and the sheriff said, "I have found her."

Patrick Brennan testified at James Farmer's trial, much as he had at the trial of Mary Farmer, repeating as he had so many times the story of how he came home from work to find his wife missing, of the nightmarish experience of being kicked out of his own house by his neighbor who claimed he had

113

bought it and of the search for, and discovery of, his wife's body in the trunk. Alice Doran, Farmer's sister, again testified that she was asked by Mary Farmer to take the deed to Watertown and have it recorded. After visiting the office where attorney Francis P. Burns had drawn and executed the deed for someone proclaiming to be Sarah Brennan and learning that the woman he saw didn't match the description of Sarah Brennan, but rather of Mary Farmer, Mrs. Doran became very concerned that something criminal was going on. She said she asked her brother several times if he had ever spoken to Sarah Brennan about transferring the deed, and he admitted he hadn't—that he had only spoken to Patrick about it the day he evicted the poor guy from his own property. Many of the witnesses called to the stand in Mary Farmer's trial returned to the stand in the James Farmer murder trial. And when all was said and done, when attorneys for the people and attorneys for the defendant had pulled out all the stops and put the best spin they possibly could on the now-familiar testimony, the jury reached its verdict: guilty. Then, just as Justice DeAngelis was about to pronounce the sentence, a motion for a new trial was made, when Attorney Kellogg said he believed that a sermon preached at the All Souls Church the previous Sunday had prejudiced some members of the jury who were in attendance at that service. The pastor was brought in and asked to read the entire text of his sermon to see if it was, in fact, something that might sway the jury. But the judge saw nothing in it that he thought would influence a juror and no reason to delay his pronouncement of sentencing. Thus, a full year after the deed that started the whole mess was forged, James Farmer was sentenced to die in the electric chair, like his wife, and he had only two to four months to come to terms with his fate.

While James Farmer's defense attorneys set to work on his appeal, he was placed in a cell in death row at the Auburn Prison. Mary Farmer was nearby, in the Auburn Women's Prison, with her execution having been temporarily stayed by a futile appeal. The couple was permitted to see each other just twice, briefly, before Mary Farmer's execution on March 31, 1909, but they were never allowed to touch or to speak in private. James Farmer was moved to another part of the prison on his wife's execution day to spare him from hearing Mary as she was led to the execution chamber. She would be accompanied only by Father Hickey, her spiritual advisor who had prayed with her in the days leading up to her execution, and the two

The Gruesome "Watertown Trunk Murder"

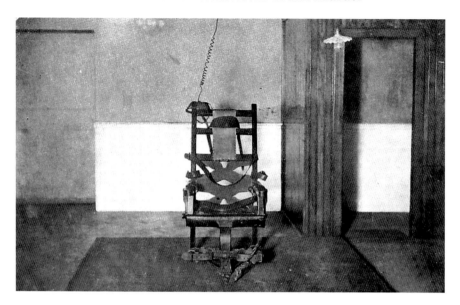

Postcard of the electric chair, Auburn Prison. *Published by W.H. Zepp, circa 1914.*

female attendants who had remained constantly at her side since she had first arrived at Auburn. The *Watertown Re-Union* of March 31, 1909, said, "The Farmer woman walked unfalteringly to the death chair. Her eyes were half closed, and she saw nothing of the death chair and rows of witnesses. In her hands, she clasped a crucifix, and as she was being strapped in the chair, Father Hickey stood at her side and offered prayers for the dying." The prison physician acknowledged that Farmer was dead with the first shock, but to quell the residual muscle tremors quickly, two more contacts were made, each with 1,840 volts of electricity shooting through her body. After the physicians pronounced her dead, her body was removed for autopsy and then, as directed by her husband, it was laid to rest in St. Joseph's Cemetery near Watertown.

Previously, Father Hickey had said, "Mrs. Farmer will die a good Catholic and will go to her death bravely. It may be, though I cannot say positively, that some statement may be made by Mrs. Farmer to the public. If so it will not be given out until after the execution." The time had now come to release the statement Mrs. Farmer wrote and addressed to Father Hickey the Sunday before. It was in response to his telling her that, if she could truthfully exonerate her husband, she should do so before it was too late. This, she did

eagerly, signing her handwritten statement—with her *real* name—before a notary that she requested on March 28. It said:

> *To Rev. J.J. Hickey:*
>
> *My husband, James D. Farmer, never had any hand in Sarah Brennan's death, nor never knew anything about it till the trunk was opened. I never told him anything what had happened. I feel he has been terribly wronged. James D. Farmer was not at home the day the affair happened, neither did James D. Farmer ever put a hand on Sarah Brennan after her death. Again, I wish to say as strongly as I can that my husband, James D. Farmer, is entirely innocent of the death of Sarah Brennan, that he knowingly had no part in any plans that led to it and that he knew nothing whatever about it.*
>
> *(Signed) MARY H. FARMER.*
>
> *Subscribed and sworn to before me this 28th day of March, 1909.*
>
> *B.F. WINEGAR*
>
> *Notary Public, Cayuga County.*

James Farmer's second trial began on February 22, 1910. The same witnesses who had been called for Mary Farmer's trial and James Farmer's first trial were brought in again. And the same attorneys who had represented him at his first trial would represent him at the second, along with E.R. Wilcox, who had defended Farmer's wife. District Attorney Fred B. Pitcher, assisted by Floyd S. Carlisle, tried the case for the people. According to the *Herald,* "The evidence was about the same as in his first trial. The prosecution tried to show his presence in the house at the time the killing took place and tried to show that he knew of it then or immediately afterwards. The defense offered evidence to show that he was not at the house at the time, and that his actions afterwards showed a man free from any guilty knowledge." (That evidence included his suggestion that the sheriff should break the trunk open when the keys could not be found.) With the very first vote taken of the jury at 7:15 p.m., all twelve men unanimously agreed on a verdict of "Not guilty." Farmer would leave the Jefferson County Courthouse that day a free man.

The *Herald* said:

> *Shortly after 9 o'clock, Judge Emerson put in an appearance. The jury filed in a moment later. The courtroom was in absolute silence, but no*

sooner had the foreman uttered the words, "not guilty," than the courtroom resounded with hand clapping. One woman jumped up and shouted, "Good, good, good." Judge Emerson rapped loudly for order, commanding the court attendants to bring anyone forward that had been seen taking part in the demonstration. As the jurymen left the enclosure, Farmer shook hands and thanked each. Later on, men and women pressed forward and shook Farmer's hand. Farmer was visibly affected by his good fortune.

THE BURLINGAME MURDER-SUICIDE

CHAUMONT, 1922

On Saturday, August 19, 1922, Roy C. Burlingame left home for a few hours to go out, telling his wife of two and a half years that he'd be back later. Jessie Burlingame was the daughter of Mr. and Mrs. George Dillenbeck and had lived in Chaumont most of her thirty-one years. Roy, who was forty-three years old, was her second husband. He conducted an automobile business on State Street in Watertown and was well known in the industry because he often participated in auto shows. The prominent couple lived in a lovely old stone home that had been built around 1772 by Squire Preston P. Gaige. It had been in the Dillenbeck family for fifty years.

That summer night in 1922, Jessie was not feeling well. In fact, she hadn't felt well since an operation several months prior, according to relatives, and the Chaumont couple had been arguing with greater frequency. Things were not happy on the home front. Jessie's brother, Alvin Dillenbeck of nearby Point Salubrious, stopped by to visit and check on his sister after Roy went out that night. When he left late in the evening, Roy had still not returned home. The next morning, Dillenbeck stopped by the house again and, finding no sign of the couple stirring from within, he solicited the aid of police justice W.H. Robbins and Deputy Sheriff Frank Rogers. The men broke down the door and found the Burlingames dead, each the victim of fatal gunshot wounds. Jessie Burlingame was lying on top of the revolver, in the front area of the house, while Roy Burlingame's bullet-riddled body was

found on the bathroom floor. District Attorney E.R. Wilcox, Undersheriff Brumley C. Wilde and Sheriff Ernest Gillette were called in to investigate.

Reconstruction of the crime, and interviews with several individuals, yielded the following findings, according to the *Cape Vincent Eagle* of August 24, 1922:

> *Mr. Burlingame, who had been out during the evening, arrived home after Mr. Dillenbeck left at 11 o'clock…Mr. Burlingame was preparing for his bath when his wife opened fire on him with a .38 caliber revolver. The gun has been identified as Mrs. Burlingame's property.*
>
> *The first shot entered Burlingame's nose and came out of his mouth, splitting the bullet and knocking out two of his teeth. The man turned and started toward his wife, and either grabbed or struck the hand in which she held the weapon, for a bullet was found lodged in the ceiling. The third shot was fired at short range, leaving powder marks on the body. The bullet struck him in the shoulder and tore down through his heart, killing him instantly.*

Jessie then ran to the front room, where she shot herself through the heart. She died instantly. After the coroner's inquest, the bodies were removed from the home in twin gray caskets. Although the precise time of the tragedy is unknown and there were no witnesses to the crimes, blood stains and the position of the bodies, as well as the location of the gun, made county officials confident that Mrs. Burlingame was solely responsible for taking her husband's life and then her own. Even though the case seemed cut and dry, questions have always remained regarding Jessie's reason for the tragic murder-suicide. A 1999 *Watertown Daily Times* article called "In Chaumont, a Favorite Haunt, Full of Spirit" claimed, for example, that jealousy may have been the impetus that caused Jessie to act as she did; or perhaps it was the agony of an excruciating toothache. The article later mentioned rumors that both spouses may have been unfaithful and said District Attorney Wilcox speculated, at the time, that Dillenbeck may have threatened his wife with divorce after learning of her infidelity. Early news articles from 1922 said Jessie was "of a highly nervous disposition, petulant and headstrong" and that she may have shot Roy Burlingame "in a fit of uncontrollable anger and through fear of exposure."

Jessie Burlingame was survived by her mother, Emma Dillenbeck, and her brother, Alvin, as well as a couple of aunts, one of whom was co-owner of the couple's home. Roy Burlingame was survived by his father, who lived in Boonville, and his brother, Walter, of Watertown. Two months after the murder-suicide, Jessie's heirs said they did not object to Roy's father and brother sharing the estate.

The *Journal and Republican* of October 26, 1922, said:

> *Burlingame left a small estate, but attorneys for heirs of both have been investigating reports of equity in an insurance policy held by Burlingame. At least one policy lapsed through failure to meet the premium within the year. Although relatives of neither husband nor wife admit knowledge of a policy in force on August 20, it is known that facts concerning the deaths were investigated on behalf of an insurance corporation. This inquiry, it is understood, to have concerned the possibility of the wife surviving the husband, but its purpose has not been revealed. Under the coroner's verdict of murder, attorneys say, the wife could not inherit, had she survived... Even should the appearance of a life insurance equity increase the estate, the outcome would not be influenced, as lawyers state that an heir could not inherit, having killed the testator.*

As it turned out, Roy Burlingame *did* have a Travelers Insurance policy for $10,000, and ultimately, the court ordered the heirs of both Roy's and Jessie's families to equally divide the policy. Thus, the final chapter in another tragic Jefferson County crime story was written, and the final story in this book of horrors is brought to a close.

BIBLIOGRAPHY

BOOKS & REPORTS

Farnsworth, Cheri. *Haunted Northern New York Volume 4*. Utica, NY: North Country Books, 2010.

"People v. Farmer (Court of Appeals of New York, Oct. 19, 1909.)" *The Northeastern Reporter*. St. Paul: West Publishing Co., 1910.

Revai, Cheri. *Haunted Northern New York*. Utica, NY: North Country Books, 2002.

NEWSPAPERS

Cape Vincent Eagle. "Double Tragedy at Chaumont." August 24, 1922.

———. "Farmer and Wife Both Indicted." May 21, 1908.

———. "Hanging of Hiram Smith, Whom Many Believed Innocent, in Watertown, Is Recalled." March 28, 1929.

———. "Hiram W. Smith." December 10, 1914.

———. "Murder Near Great Bend! The Murderer Commits Suicide!" January 16, 1873.

———. Note regarding Edward G. Haynes. December 21, 1916.

Daily Journal. "The Abortion Murder." January 18, 1873.

———. Note regarding Frank Ruttan. February 23, 1876.

———. Note regarding Sarah Conklin. December 10, 1875.

Jefferson County Journal. "A Chapter of Horrors." January 16, 1872.

Journal & Republican. "Alleged Confession." February 13, 1876.

———. "Back to Auburn Prison." November 27, 1913.

———. "Burlingame's Relatives to Inherit His Estate." October 26, 1922.

———. "Court Orders Estate Split." September 25, 1924.

———. "Kellogg Opposes Parole of Haynes." July 12, 1917.

———. "Murder Recalled by Brennan's Death." December 9, 1918.

———. "Wife Murders Her Husband Then Turns Gun on Herself." August 24, 1922.

New York Times. "Murder and Suicide: Shocking Murder Discovered at Great Bend, N.Y.—The Murderer Is Arrested and Commits Suicide." January 12, 1873.

Ogdensburg Daily Journal. "Mrs. Farmer Electrocuted; Exonerates Her Husband." March 29, 1909.

St. Lawrence Republican. Note regarding Henry Miles. November 21, 1894.

Watertown Daily Times. "In Chaumont, a Favorite Haunt, Full of Spirit." October 31, 1999.

Watertown Herald. "Brevities (regarding Mary Farmer)." July 4, 1908.

———. "Did Allen Shoot?" October 9, 1897.

———. "End of the Trial." October 30, 1897.

———. "An Expert Talking." October 2, 1897.

———. "Farmer Not Guilty." March 5, 1910.

———. "Farmer Trial Begun." October 24, 1908.

———. "Funeral of Henry Miles." September 20, 1902.

———. "The Great Trial—Weaving the Web to Convict Haynes." September 18, 1897.

———. "The Grumbler's Pen: Recalling the Story of the Last Hanging." June 6, 1908.

———. "Hanging of Evans." May 16, 1908.

———. "The Harbor Murder." April 24, 1897.

———. "Henry Miles—Convicted of Murder in the First Degree." March 17, 1894.

———. "In Prison for Life." November 6, 1897.

———. "Looks Like Murder." May 15, 1897.

———. "Must He Die?" March 10, 1894.

———. Note regarding Henry Evans's axe murders. November 10, 1900.

———. Note regarding Henry Miles. December 1, 1894.

———. Note regarding Mary Ockwood. June 5, 1897.

———. "Shot Dead: A Rochester Woman Killed Near Evans Mills." December 19, 1893.

———. "Shot in the Neck." May 1, 1897.

———. "A Startling Story—Tracing the Murder Home to Allen." September 25, 1897.

———. "Town Crier (regarding Henry Miles)." December 1, 1894.

———. "Town Talk (regarding Henry Miles)." November 17, 1894.

Watertown Re-Union. "The Abortion Case." January 18, 1877.

———. "The Antwerp Sensation." January 23, 1873.

———."A Cold Blooded Murder." December 6, 1893.

———. "The Conklin Murder." December 9, 1875.

———. "The Conklin Tragedy." December 16, 1875.

———. "Court of Sessions (People vs. George Hewitt)." May 31, 1877.

———. "Court of Sessions (People vs. George Powell)." February 22, 1877.

———. "Crouch Acquitted." May 19, 1897.

———. "Crouch Stood the Test." October 20, 1897.

———. "Cruel Murder: With Head Crushed, Body Jammed in Trunk." April 29, 1908.

———. "Farmer and Wife Plead Not Guilty." May 6, 1908.

———. "Farmer Is Guilty." November 4, 1908.

———. "Farmers Are Held for Grand Jury." May 9, 1908.

———. "The Farmer Trial." June 17, 1908.

———. "The Farmer Trial." June 18, 1908.

———. "The Farmer Trial." February 26, 1910.

———. "Fighting for the Brennan House." July 18, 1908.

———. "Fixes Crime on Mrs. Farmer." May 13, 1908.

———. "Frank Ruttan—Murderer of Sarah Conklin." May 11, 1876.

———. "Hatchet Found at Brownville." May 13, 1908.

———. "Haynes Now in Jail." May 26, 1897.

———. "He Killed Mary Ward—Sentence Served Out." September 17, 1902.

———. "The Henderson Crime." May 19, 1897.

———. "Henry Miles' Case." November 10, 1894.

———. "Indian Woman Killed." May 12, 1897.

———. "In Prison for Life." November 3, 1897.

———. "It is Still a Mystery—Sackets Harbor Murder Puzzles the Detectives." May 5, 1897.

———. "The Jury Acquits." March 5, 1910.

———. "Miles Convicted." March 14, 1894.

———. "Miles Is Spared." December 12, 1894.

———. "Miles Sentenced." March 21, 1894.

———. "Mrs. Farmer Electrocuted." March 31, 1909.

———. "The Murder Case." May 13, 1908.

———. Note regarding Alzina Sprague. March 13, 1873.

———. Note regarding Mary Ockwood. May 19, 1897.

———. Note regarding People vs. George Powell. February 28, 1878.

———. "On Trial for His Life." September 8, 1897.

———. "The Powell Drowning Case." March 16, 1876.

———. "Preparing for Trial." September 1, 1897.

———. "The Prosecutor's Side." September 15, 1897.

———. "The Rutland Murder." December 9, 1875.

———. "Ruttan's Confession." May 18, 1876.

———. "The Sackets Tragedy." April 28, 1897.

———. "Seeks Recovery." June 27, 1908.

———. "A Serious Charge: A Carthage Doctor Charged with a Grave Crime." January 11, 1878.

———. Story regarding Conklin murder. May 11, 1876.

———. "Suicide Near Sterlingville." March 16, 1876.

———. "A Terrible Tragedy." April 21, 1897.

———. "Took Poison." October 2, 1889.

———. "The Trial of Miles." March 14, 1894.

———. "Trunk Undoing of Mrs. Farmer." January 27, 1909.

———. "The Ward Murder." December 13, 1893.

———. "Wilbur Crouch Dead." December 13, 1902.

ONLINE SOURCES

"Cabin Fever." Wikipedia, the free encyclopedia. http://en.wikipedia.org/wiki/Cabin_fever.

"Evans-Gaige-Dillenback House." National Register of Historical Places, New York, Jefferson County. www.nationalregisterof historicplaces.com.

"Henry Evans." JeffCo Wiki. http://jeffco.wikispaces.com/Henry+Evans.

"Jefferson County, New York." Wikipedia, the free encyclopedia. http://en.wikipedia.org/wiki/Jefferson_County,_New _York.

"Seasonal Affective Disorder." Wikipedia, the free encyclopedia. http://en.wikipedia.org/wiki/Seasonal_affective_disorder.

"Slaughter Hill." JeffCo Wiki. http://jeffco.wikispaces.com/Slaughter+Hill.

"Watertown (city), New York." Wikipedia, the free encyclopedia. http://en.wikipedia.org/wiki/Jefferson_County,_New_York.